COLOR

A practical guide

to **COLOR AND ITS USES IN ART**

Brimming with creative inspiration, how-to projects, and useful information to enrich your everyday life, Quarto Knows is a favorite destination for those pursuing their interests and passions. Visit our site and dig deeper with our books into your area of interest: Quarto Creates, Quarto Cooks, Quarto Homes, Quarto Lives, Quarto Drives, Quarto Explores, Quarto Gifts, or Quarto Kids.

Inspiring | Educating | Creating | Entertaining

First Published in 2017 by Walter Foster Publishing, an imprint of The Quarto Group. 6 Orchard Road, Suite 100, Lake Forest, CA 92630, USA.
T (949) 380-7510 **F** (949) 380-7575 **www.QuartoKnows.com**

Walter Foster Publishing titles are also available at discount for retail, wholesale, promotional, and bulk purchase. For details, contact the Special Sales Manager by email at specialsales@quarto.com or by mail at The Quarto Group, Attn: Special Sales Manager, 401 Second Avenue North, Suite 310, Minneapolis, MN 55401 USA.

ISBN: 978-1-63322-272-4

Digital edition published in 2017
eISBN: 978-1-63322-455-1

Project editing and content development by Elizabeth T. Gilbert
Cover design and page layout by Melissa Gerber

Printed in China
10 9 8 7 6 5 4 3 2

Table of Contents

INTRODUCTION

Color is one of the most fascinating elements of art. It functions alongside line, shape, form, value, texture, and space to create dynamic, meaningful works of art. More than any other element, color shapes the way we see the world by evoking emotion—it can be stimulating, calming, unsettling, or mysterious. Color is also an area of scientific study. From how the eye perceives color wavelengths to the chemical makeup of pigments, topics under the "color" umbrella are seemingly endless.

This book covers color as it relates to art and painting, offering information on color theory and important terms, color psychology, pigments, and color mixing. The final chapter allows you to put your new color knowledge into practice through a selection of six painting demonstrations in watercolor, acrylic, and oil. Meet the contributing artists on the following page!

MEET THE ARTISTS

Patti Mollica has been a fine artist and professional illustrator for more than 30 years. Her artwork is known for its fearless use of color and uninhibited brushwork. She delights in painting the world around her in a bold, decisive style with hues that are intense, brilliant, and contemporary. For more information, visit pattimollica.com.

Joseph Stoddard is an artist and designer based in Pasadena, California. Following his motto "Never let reality stand in the way of a good painting," Joseph wants viewers to experience an emotional response from his paintings and to be charmed and surprised by his interpretations. For more information, visit josephstoddard.com.

Maury Aaseng began his career in freelance illustration in 2004 in San Diego, California, where he created graphics for young-adult nonfiction. His work since then has expanded into instructional line-drawn illustrations, cartooning, medical illustration, and more traditional media such as drawing and watercolor. He now lives in Duluth, Minnesota, with his wife and daughter. For more information, visit mauryillustrates.com.

Jan Murphy is an artist based in Menlo Park, California, where she lives with her photographer husband, Ed. Inspired by the Impressionists and fascinated by light and the interaction of color, you might find Jan painting *en plein air* in Europe, Hawaii, Massachusetts, or the San Francisco Peninsula. For more information, visit janmurphyartworks.com.

Originally from Victoria, British Columbia, **David Lloyd Glover** is an artist with a long and successful career in oil and acrylic painting. Influenced by impressionist painters of the past, David's soft yet vivid approach pairs well with his penchant for painting natural settings and elegant gardens. For more information, visit davidlglover.com.

CHAPTER 1:

Color Basics & Painting Concepts

To have a meaningful discussion about color, we must be familiar with its scientific origins and the vocabulary used to describe its characteristics. Then we can build on this knowledge to discuss color as it is used in art to craft a message—from directing the viewer's eye to hinting at a particular mood and accurately suggesting a sense of time and place. This broad chapter covers the following topics:

- What Is Color?
- Color Terms & Properties
- Color, Light & Shadow
- Color Relativity
- Color Psychology
- Color & Mood
- Color Schemes
- Color & Composition
- Infusing Color

WHAT IS COLOR?

Color is a phenomenon of perception and reaches our eyes in a way you may not expect. Colors are actually wavelengths of light; when an object is red, it is reflecting red wavelengths and absorbing all other colors. In other words, you could say that a rose isn't red—it's *reflecting* red.

The first person to present this idea was Sir Isaac Newton (1642-1727) in the late 1600s. He conducted and published a series of experiments involving prisms, light, and color, which form the basis of our current understanding of color. These experiments involved refracting white light through a prism—a simple triangular glass object that separated light waves into individual colors. The results revealed that light could actually be broken down into seven individual colors: red, orange, yellow, green, blue, indigo, and violet. Until this discovery, it was assumed that a prism somehow "colored" the light passing through it. To prove this wrong, Newton reversed the process: He projected the colors back into the prism, which resulted in pure white light. Artists and scientists alike were amazed by this breakthrough discovery that *light is the source of all color.*

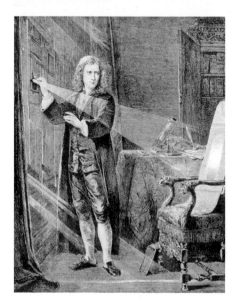

Scientist Sir Isaac Newton provided the foundation for color theory as we understand it today.

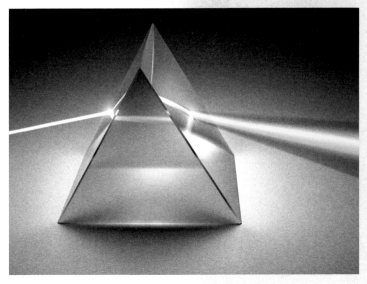

As white light hits a prism, the light refracts and separates into the colors of the rainbow.

Light is made of electromagnetic waves produced by a light source, such as a candle, an electric light bulb, or the sun. These waves exist in varying lengths, which correspond to the different colors we see. For example, red is the longest wavelength, and violet is the shortest. The colors that we see when light strikes an object are the result of certain wavelengths (individual colors) being absorbed by the object while other wavelengths are being reflected back to us. Those reflected back to us are the colors that we see. They are focused by the lens of our eye and projected onto our retina. Because physiology differs from one person to the next, we each perceive color slightly differently. This makes our perception of color somewhat subjective, adding to the fascinating nature of color theory.

LIGHT & REFLECTED COLOR

As light hits a yellow object, yellow is reflected; all other colors are absorbed.

As light hits an orange object, yellow, orange, and red are reflected; all other colors are absorbed.

Color Terms & Properties

THE COLOR WHEEL

Now that we know a little about the science behind color, how do we use our knowledge of light and color to organize a visual system that we can use to achieve our artistic goals? Fortunately, much of this organization has been done for us. The easiest way to view color relationships is through a circular diagram called the "color wheel"—a visual organization of color hues that follow a logical order around a circle. Seeing the colors organized in this fashion is helpful for color mixing and choosing color schemes. Many accomplished colorists throughout history, such as Wilhelm Ostwald, Dr. Herbert Ives, Sir Isaac Newton, and Albert H. Munsell, developed their own variations of color charting, but the 12-hue wheel pictured here is the most common model used by artists today.

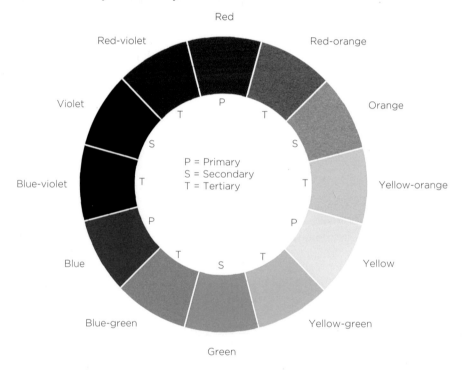

Primary, Secondary & Tertiary Colors

The color wheel helps us see relationships between primary, secondary, and tertiary colors. The wheel's three primary colors are red, yellow, and blue, which are positioned at three evenly spaced points around the circle. The three primary colors are so named because they can't be created by mixing any other colors on the wheel. We can create a multitude of other colors by combining red, yellow, and blue in various proportions, but we can't create the three primaries by mixing other colors.

This color wheel is further broken down into three secondary colors: orange, green, and violet. You can create these colors by combining two of the primaries. For example, red and yellow produce orange, blue and red produce violet, and yellow and blue produce green. Also shown in the color wheel are six tertiary colors, which are created by mixing each primary color with its neighboring secondary color. These colors include red-orange, yellow-orange, yellow-green, blue-green, blue-violet, and red-violet.

Complementary Colors

Complements sit directly opposite each other on the color wheel. For example, red sits opposite green, blue sits opposite orange, and yellow sits opposite violet. These colors are considered "opposites" in their hues and hold the maximum amount of color contrast possible. Just as white is considered the opposite of black, red is the opposite of green. When mixed together, they form a dull gray, brown, or neutral color. Below are a few tips for effectively using complementary colors in painting.

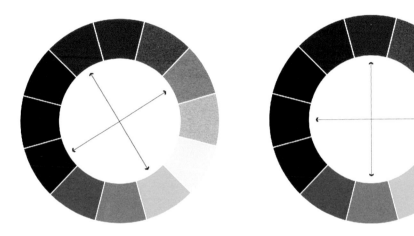

TIPS FOR USING COMPLEMENTS

- To lower the brightness or intensity of a color, add a little of its complementary color.
- When next to each other, complementary colors appear brighter and more intense.
- The shadow color of an object often contains the object's complementary color; for example, the shadow of a green apple contains some red.
- Complements are often used in a painting's color scheme; one complement serves as the dominant color, and the other serves as a secondary or focal point color.

Analogous Colors

Analogous colors are adjacent (or close) to each other on the color wheel. When used together in a painting, analogous colors create unity because the colors are already related. They can also be used in color mixing to brighten or darken each other. For example, add yellow to brighten a yellow-green, or add green to darken a yellow-green.

THE QUALITIES OF COLOR

Hue, saturation (or intensity), and value are the three characteristics that help us describe and categorize a color. For instance, if we say an object is red, we can more specifically describe the color by answering the following questions: Is it an orangey red or a crimson red? Is it brilliant or muted? Is it light or dark? With an understanding of these common properties, you can identify and describe any color.

ALTERING HUE, SATURATION & VALUE

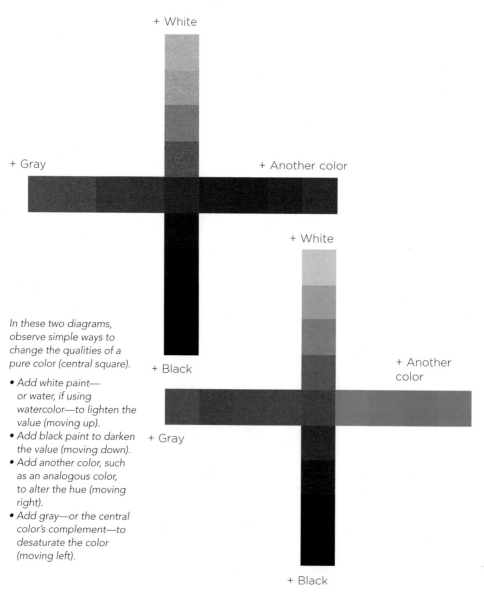

+ White

+ Gray

+ Another color

+ Black

+ White

+ Another color

+ Gray

+ Black

In these two diagrams, observe simple ways to change the qualities of a pure color (central square).

- *Add white paint— or water, if using watercolor—to lighten the value (moving up).*
- *Add black paint to darken the value (moving down).*
- *Add another color, such as an analogous color, to alter the hue (moving right).*
- *Add gray—or the central color's complement—to desaturate the color (moving left).*

HUE

The beauty of the color wheel is that it shows us the relationships between the various hues. The term "hue," which is often used interchangeably with the word "color," refers to the family to which a particular color belongs. Rose, burgundy, magenta, and candy apple are all in the red hue family. Chartreuse, leaf green, and seafoam are all in the green hue family, and so on. In essence, when one uses the word "color," one is referring to its hue.

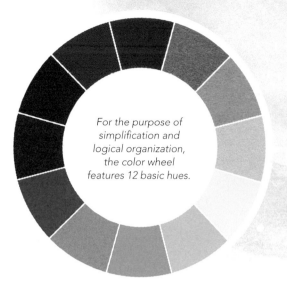

For the purpose of simplification and logical organization, the color wheel features 12 basic hues.

Common Hues of Blue

Below are five swatches of blue watercolor paints that show different hues within the same color family. When building your palette of paint colors, it's a good idea to have a few hues of each primary color on hand.

Phthalo blue: a greenish blue

Cobalt turquoise light: a bright, greenish blue

Cerulean blue: a bright, grayish blue

Ultramarine blue: a cool, reddish blue

Cobalt blue: a pure blue

SATURATION & INTENSITY

A color's saturation, also called its "intensity" or "chroma," refers to its level of brilliance or dullness. A highly saturated color is very vibrant. Many beginners who strive to create brilliant, colorful paintings work with a palette of only—or mostly—highly saturated colors. This can defeat their purpose, however, because when too many brilliant colors are placed together in the same painting, each color competes for the viewer's attention. An effective way to use saturated color is in conjunction with unsaturated color (or *neutrals*), so that some parts of the painting demand the attention while others fade back and play supportive roles.

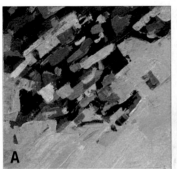

Brilliantly saturated colors (A) and muted tones (B) can be lovely on their own, but often the key to a successful work is a balance of the two (C).

Neutral Colors

Neutral colors are low in saturation. Although they are not on the color wheel, these beautiful tones appear frequently in nature and can have a calming effect in art. Neutrals include browns and grays, both of which contain all three primary colors in varying proportions. Neutral colors are often dulled with white or black. Artists also use the word neutralize to describe the act of dulling a color by adding its complement.

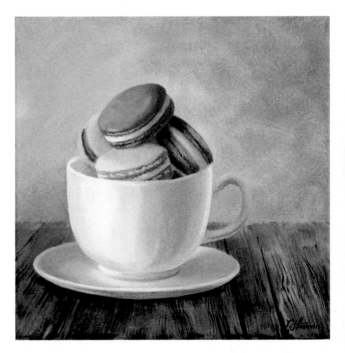

In this painting, acrylic artist Varvara Harmon employs mostly neutrals within the composition to keep the viewer's focus on the more colorful macarons.

VALUE

Within each hue, you can achieve a range of values—from dark shades to light tints. However, each hue has a value relative to others on the color wheel. For example, yellow is the lightest color and violet is the darkest. To see this clearly, photograph or scan a color wheel and use computer-editing software to view it in grayscale. It is also very helpful to create a grayscale chart of all the paints in your palette so you know how their values relate to one another.

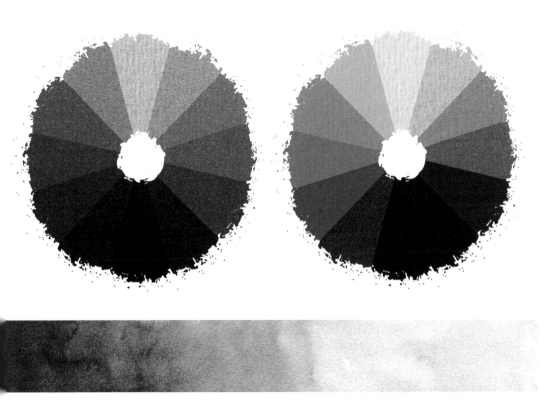

Besides a color's inherent value on the wheel, a hue itself can vary in value. The simplest way to explore a color's range of value is to create a value scale. In this example, work from left to right in watercolor, starting with a very strong wash and adding more water for successively lighter values.

Color & Value Patterns

For most paintings to be successful, there should be a good value pattern across the painting, which means a clear and definite arrangement of dark, middle, and light values. This will create an effective design, which appeals to our innate sense of aesthetics and what is pleasing to the eye. It also helps communicate the point of your painting in a clear and uncluttered manner. Keep in mind that these values should not be equal in a painting but rather predominantly light or dark. Equal amounts of light and dark result in a static image that lacks movement, drama, and interest.

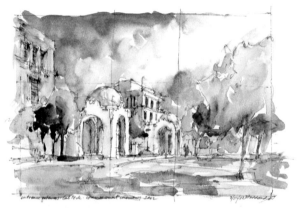

Predominantly light painting

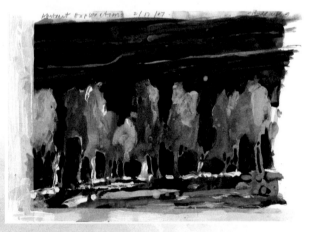

Predominantly dark painting

CHARTING THE VALUES OF YOUR PALETTE

This chart shows the relative values of each color in a palette. To do this for your own palette, first create a gray value scale of ten steps (shown along the bottom). Then create and cut out a swatch of each color in your palette. Squint at your swatches and gauge their values against the scale you created. Knowing where the general value of each color falls on the scale can help you know which colors to combine for effective patterns of value.

TIP

A good exercise is to make a black-and-white print of your painting. Does it read well? Can you see a separation of elements and objects without having to rely on the colors? If so, well done—your values are working for you. Too often we rely on the colors to get the point across, and we're disappointed when it doesn't happen.

Color vs. Value

To understand the importance of value, try this exercise. Re-create a painting or a photograph using an unconventional color palette while staying true to the pattern of values. The final image will still "read" well, despite the inaccurate colors.

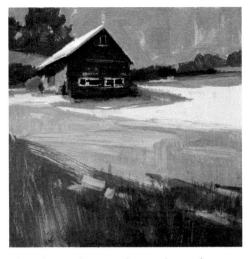

Shown here is the original painted scene featuring a dynamic value pattern and realistic hues. Now we'll paint the same scene using different colors that match the value sketch.

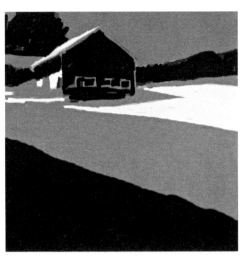

Above is a three-value sketch of the scene using black, white, and gray. This will help you keep your values in check as you choose and mix colors for the painting.

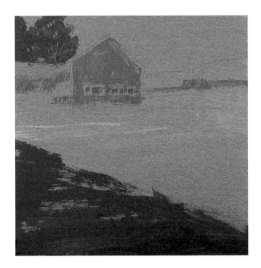

Step 1
Use a large brush to cover your canvas with strokes of a bright, warm pink. Once dry, sketch the scene on top and block in the darkest values with variations of blue.

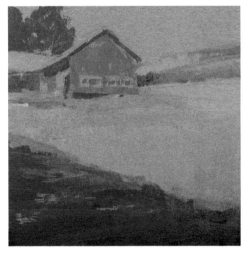

Step 2
Add greens and browns to block in the midtone field and hills. Keep your brushwork loose as you stroke in the direction of grass growth.

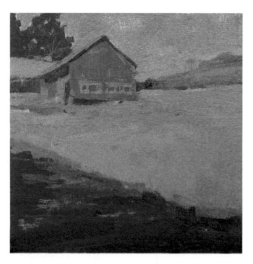

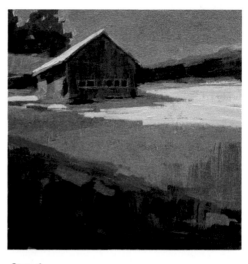

Step 3
Then paint the midtone sky with a purple mix, allowing some of the pink from step 1 to show through for interest.

Step 4
Now add the lightest areas using cool yellow tints. Finish by defining a few details, such as the window sills.

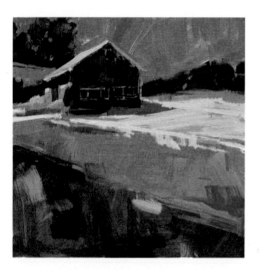

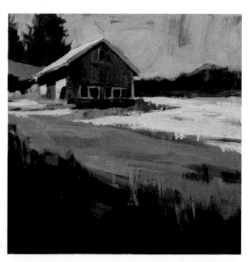

Above are alternative color schemes that adhere to the same general value pattern.

Tints, Tones & Shades

The 12-hue color wheel shows us basic color relationships, but it does not show the various levels of color saturation and values that are possible. We need to know how to make a color lighter or darker without changing its hue, as well as how to desaturate a color while maintaining its value. This leads us to tints, shades, and tones. A tint is a color plus white; when painting with opaque pigments such as oils or acrylics, simply add white paint to any color to create a tint. A shade is a color that has been darkened with black paint. A tone is a color that has been mixed with black and white (or gray). Most colors we see in nature are tones; very few are full-intensity hues.

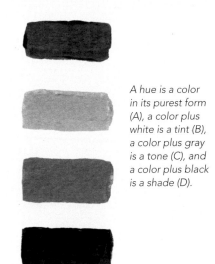

A hue is a color in its purest form (A), a color plus white is a tint (B), a color plus gray is a tone (C), and a color plus black is a shade (D).

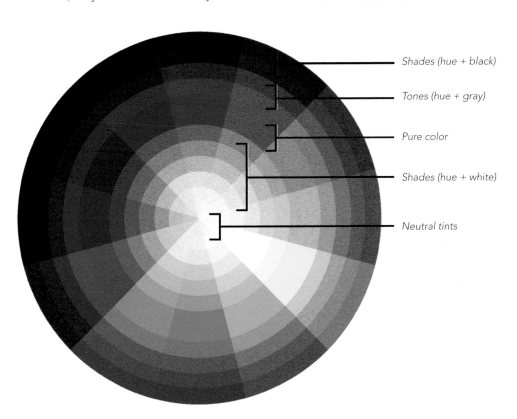

Shades (hue + black)

Tones (hue + gray)

Pure color

Shades (hue + white)

Neutral tints

Alternative Color Wheel *The 12-hue color wheel we have referred to thus far shows colors in their pure forms, but it neglects to show the many possible variations within a color. This alternative color wheel incorporates tints, shades, and tones.*

TEMPERATURE

Color temperature refers to the feeling one gets when viewing a color or set of colors. Generally, yellows, oranges, and reds are considered warm, whereas greens, blues, and purples are considered cool. When used within a work of art, warm colors seem to advance toward the viewer, and cool colors appear to recede into the distance. This dynamic is important to remember when suggesting depth or creating an area of focus.

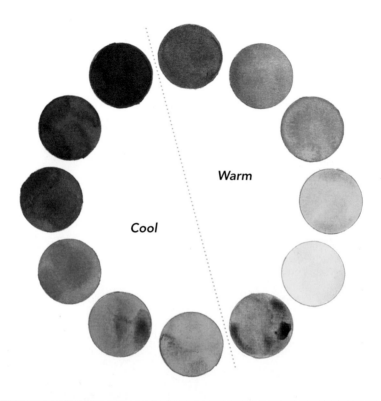

Warm

Cool

Divide your color wheel in half by drawing a line from a point between red and red-violet to a point between yellow-green and green. This makes a visual distinction between the warm and cool colors. Granted, red-violet is a bit warm and yellow-green is a bit cool, but the line needs to be drawn somewhere—and you'll get the general idea from this.

Relative Temperature
Within individual colors, you will find warm and cool varieties. If a color leans toward red on the color wheel, it is considered warmer than a version of the color that leans blue. Relative to each other, cadmium yellow leans red and lemon yellow leans blue; therefore, cadmium yellow (far left) is warmer than lemon yellow (near left).

Combining Warm & Cool Temperatures

A painting should be primarily one temperature—either warm or cool. There should be a clear, simple message in each painting with a minimum number of variables. Also, you don't want to confuse the viewer with uncertainty. However, warm accents in a cool painting—and cool accents in a warm painting—are certainly acceptable and encouraged. Remember, you want your statement to be exciting but clear.

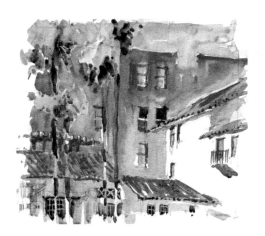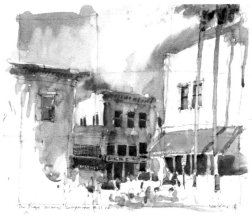

Accenting Warm and Cool Palettes These two examples show either warm or cool colors almost exclusively. The warm painting (left) suggests a hot summer day with energy in the air, and the cool painting (right) recedes into quiet and suggests a winter afternoon. In each painting, complementary accents emphasize the color theme with contrast.

The above paintings by artist Robert Moore illustrate warm and cool palettes. Compare the energy and glow of the yellow and orange autumn scene to the soothing blues and purples of the tea still life. However, notice hints of contrasting temperatures in the scenes that create effective accents, such as the patches of cool blue sky and the warm teacup.

Color, Light & Shadow

The interplay of light and shadow is a common area of focus for artists, as this can heavily influence the mood, drama, and realism of a painting. To begin understanding how light affects an object, think of it as though it is made up of three basic parts: lights, local color, and shadows. The local color of an object refers to its actual or natural color, without taking lights and shadows into account. The lights are illuminated by a light source, whether it's the sun, moon, artificial light, or candlelight. A bright, sunny day warms an object with a yellow cast, while creating cool areas of shadow. In contrast, a gray, wintery day illuminates the lights with cool tones, and its shadows appear warmer. Simply stated, the general rule is this: Warm light yields cool shadows; cool light yields warm shadows.

This pear is painted in warm light coming from the upper left, which produces cool shadows.

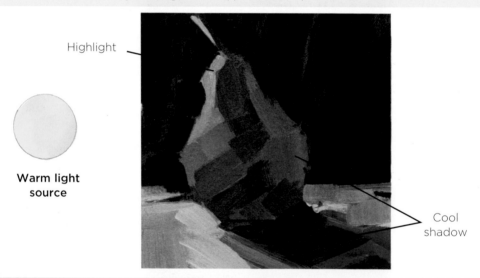

Highlight

Warm light source

Cool shadow

This pear is painted in cool light coming from the upper left, which produces warm shadows.

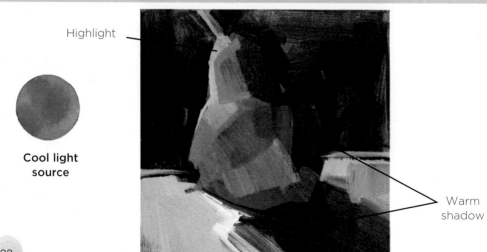

Highlight

Cool light source

Warm shadow

Visual Interest with Light & Shadow

Besides creating the illusion of form and dimension, the interplay between light and shadow also can be used to pique a viewer's interest in a scene. Because contrasting values attract the eye, incorporating subtle, natural contrasts between light and dark can add vitality and drama to a painting. For example, sunlight filtering through the leaves of a tree forms a variety of fascinating shapes that engage the viewer's interest. And sometimes patterns of light and shadow can be so compelling that they become the focus of the painting in lieu of the physical elements of the scene!

Engaging the Viewer The irregular patches of sun and a range of warm values make this scene compelling and inviting.

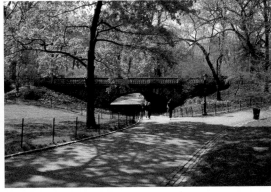

Focusing on Shadows This snapshot captures the natural, delicate balance between light and shadow. For the painting, simplify the shadows but try to retain the delicate lace-like quality that makes them so interesting.

Color Relativity

While colors are generally classified as warm or cool, they can also be relatively warm or cool within their hue. Although red is considered the warmest color, there are cool reds and warm reds. A cool red contains more blue (such as magenta), and a warm red contains more yellow (such as coral). By virtue of the relative warmness or coolness of a color, artists can manipulate space and influence how the viewer perceives a color. This leads us to the importance of color relationships. The way we perceive a color's characteristics is relative to its surroundings. By using contrasts in temperature, value, and chroma, we can make colors appear warmer or cooler, lighter or darker, and brighter or duller simply by the colors we place next to them.

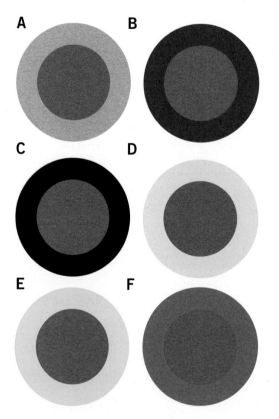

Relative Temperature A color's temperature is influenced by surrounding colors. Note how the same pink circle appears cooler set against orange (A) than blue (B).

Relative Value Our perception of a color's value depends on its surrounding color. Note how the same pink circle appears lighter in example C than in example D.

Relative Chroma A color's chroma can appear different depending on nearby colors. Note how the same pink circle appears dull against yellow (E) and bright against gray (F).

TO SUMMARIZE:

- How do you make a color appear warmer? Place a cooler color adjacent to it.
- How do you make a color lighter? Place a darker color adjacent to it.
- How do you make a color appear brighter? Place a duller color adjacent to it.

Color Psychology

HUE	SYMBOLISM	FUN FACTS
YELLOW	• Happiness • Joy • Intellect • Enlightenment • Wisdom • Warmth • Spring • Cowardice • Hazard • Illness	• The eye processes yellow first. It's often used in cautionary signage, such as a yield sign. • The yellow in a stoplight cautions us to slow down. • A "yellow card" in soccer is a warning.
ORANGE	• Extroverted • Energy • Optimism • Spontaneity • Adventure • Youthfulness • Inexpensive • Superficiality • Loudness	• Orange takes the heat and vitality of red and combines it with the sunshine of yellow. • Orange is known to stimulate the appetite. Restaurants often use orange—from a peach color to earth tones—in their décor. The color orange encourages people to eat, drink, and enjoy themselves.

HUE	SYMBOLISM	FUN FACTS
RED	• Energy • Passion • Action • Love • Anger • Aggression • Danger • War	• Red calls attention. It is highly visible. Think of a stop sign. It's interesting to note that many countries' flags feature red as one of their colors. • A "red-letter day" is a special day. • To "see red" means that one is furious.
VIOLET	• Royalty • Rich • Ceremony • Creativity • Courage • Magic • Death • Mourning • Unrest	• Violet is the most difficult color for the eye to pick up, because it has the shortest wavelength in the light spectrum. • Richard Wagner surrounded himself with violet when composing operas. • Violet is said to be an appetite suppressant. It's a rare color in natural foods.
BLUE	• Depth • Stability • Calm • Trust • Serenity • Loyalty • Sadness • Coldness	• Blue is nature's color for water and the sky. • Blue, like violet, is said to be an appetite suppressant. It's also a rare color in natural foods. • Blue ranks high as a favorite color and is often used in business communications and logos.
GREEN	• Life • Nature • Renewal • Soothing • Healing • Greed • Jealousy	• Green is a dominant color in nature and a relaxing color to view. • Green symbolizes ecology and the environment. It is used to advertise "green" products.

Color & Mood

A basic understanding of color psychology allows you to better select a palette or dominant color scheme that conveys your desired mood. Let's take a look at some common colors and their corresponding psychological values as they appear in the context of paintings by artist Patti Mollica.

YELLOW

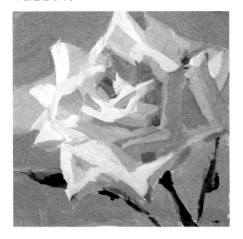

Yellow Rose by Patti Mollica. Acrylic.

Yellow is the cheerful color of sunshine. It conveys warmth, happiness, hope, and positivity. It also exudes childlike simplicity and innocence.

RED

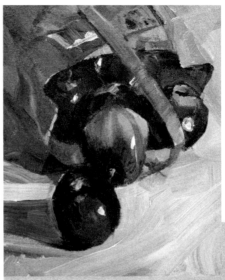

Red Macs by Patti Mollica. Acrylic.

A color commonly associated with fire and blood, red conveys energy, power, passion, and love. It stimulates excitement and has been shown to raise blood pressure and heart rate. It is used often in restaurants because it is considered an appetite stimulant.

PINK

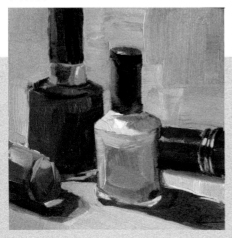

Pink Brigade by Patti Mollica. Acrylic.

Pink is a psychologically powerful color that represents the feminine principle and is associated with love and romance. Pink is thought to have a calming effect, although too much of it is physically draining and can be emasculating.

BLUE

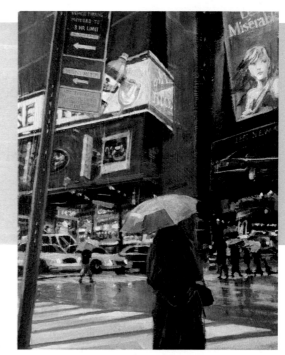

Rainy Day, Times Square *by Patti Mollica. Acrylic.*

When used in light, airy pastel tints, blue is associated with the sky, water, and feelings of serenity, relaxation, and calm. Deeper shades, however, are related to sadness and despair.

PURPLE

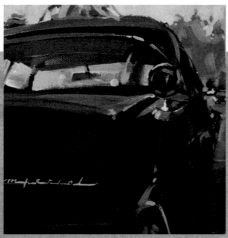

Purple Imperial *by Patti Mollica. Acrylic.*

Purple has long been associated with royalty because only aristocrats could afford the expensive pigment. During Roman times, it took 4 million crushed mollusk shells to produce one pound of purple pigment. This royal color conveys elegance, dignity, and sophistication.

BLACK

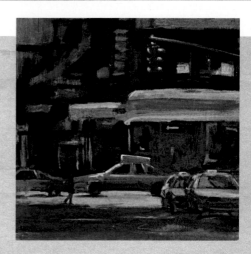

53rd and Third *by Patti Mollica. Acrylic.*

The color black (or lack thereof) is associated with fear, death, evil, negativity, formality, and solemnity. Black can be used alongside other colors to make them stand out, and it contrasts well with bright colors.

WHITE

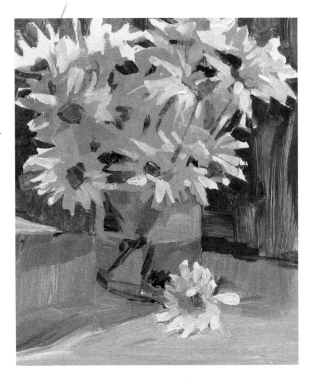

Mimi's Bouquet by Patti Mollica. Acrylic.

As the color of snow, white symbolizes cleanliness, goodness, innocence, and purity. It is considered the color of perfection.

GREEN

End the War by Patti Mollica. Acrylic.

The color of nature, green symbolizes freshness, fertility, and harmony. It is considered the most restful color to the eye and imbibes the cheeriness of yellow with the calmness of blue.

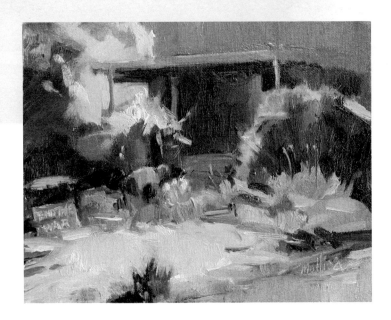

ORANGE

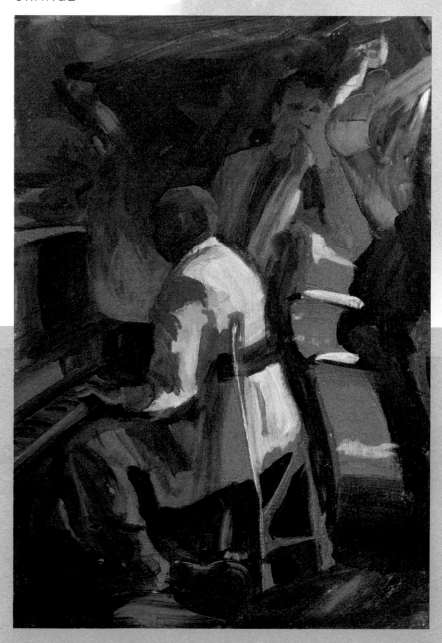

Red Hot Jazz *by Patti Mollica. Acrylic.*

The human eye perceives orange as the warmest color. Orange mimics the heat of a flame and combines the vibrance of yellow with the intensity of red. It represents enthusiasm, creativity, and invigoration.

Color Schemes

Over time, certain color combinations have been established as especially agreeable to viewers. These combinations consist of two or more colors that have a fixed relationship on the color wheel and are pleasing when viewed together (creating "color harmony"). This includes tints, tones, and shades of the colors within a scheme; simply be aware of the balance of warm to cool hues, as well as saturated to neutral colors. In this section, explore the most commonly used color schemes through a selection of paintings by artist Patti Mollica.

MONOCHROMATIC SCHEME

The monochromatic color scheme uses a single color throughout, along with variations of the color's shades, tints, and tones. While it's not known to be the most exciting color scheme, a monochromatic palette is elegant, easy on the eyes, and soothing. This is the easiest color scheme to create; all you need is your color of choice, black, and white paints.

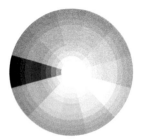

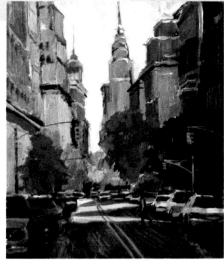

Chrysler Building by Patti Mollica. Acrylic.

ANALOGOUS SCHEME

The analogous scheme is made of colors that sit adjacent to one another on the color wheel. Most often, one color serves as the dominant color, with others used to accent and enhance the overall scheme. Although the lack of contrasting colors yields a simplistic look, this scheme—like the monochromatic—has a simple elegance that is pleasing to the eye.

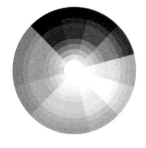

Orange on Pink by Patti Mollica. Acrylic.

TRIADIC SCHEME

The triadic color scheme uses three colors equally spaced around the color wheel (for example, red-orange, blue-violet, and yellow-green). Many artists enjoy using this scheme because, unlike the previous two, there is ample color contrast and a natural color balance. One color serves as the dominant color, while the other two act as subordinate hues.

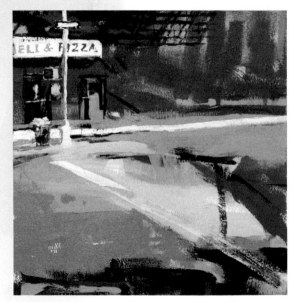

Deli & Pizza by Patti Mollica. Acrylic.

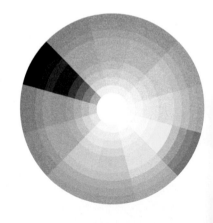

Daffy by Patti Mollica. Acrylic.

COMPLEMENTARY SCHEME

The complementary scheme offers the most visual contrast because it is made up of two colors that sit opposite each other on the color wheel. It is most successfully used when one color acts as the dominant color with the other in a supporting role. The two colors should not be of the same saturation intensity and must be visually balanced. For example, in the painting at left, the subdued purple takes up the most space of the painting but is balanced by the more saturated yellow of the flower.

SPLIT COMPLEMENTARY SCHEME

The split complementary scheme uses a color and the two colors adjacent to its complement (for example, red, yellow-green, and blue-green). This scheme still features good color contrast, but it conveys less tension than the complementary scheme.

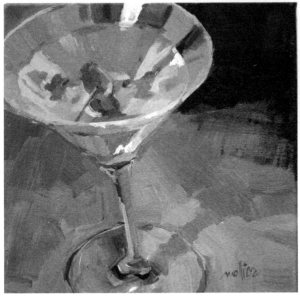

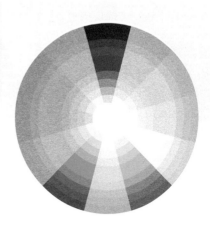

Moonshine Mama by Patti Mollica. Acrylic.

ANALOGOUS COMPLEMENTARY SCHEME

This scheme combines the analogous and complementary schemes, incorporating three side-by-side hues plus the complement of the center color (for example, red, blue-green, green, and yellow-green).

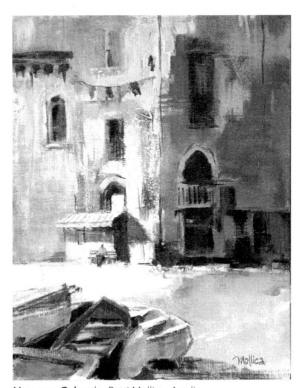

Vernazza Colors by Patti Mollica. Acrylic.

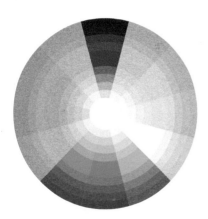

TETRAD SCHEME

The tetrad color scheme uses two hues that are separated by one color on the wheel, plus the complement of each hue (for example, red, green, orange, and blue). Because this scheme can overwhelm with visual tension, it's a good idea to choose one dominant color and accent with the rest.

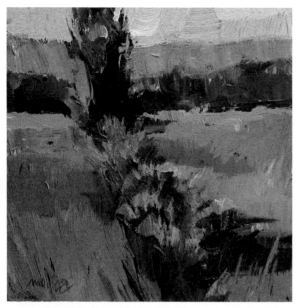

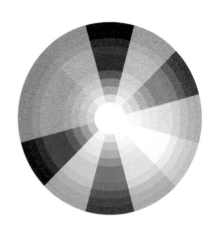

Field and Sky by Patti Mollica. Acrylic.

SATURATED SCHEME

The saturated scheme uses the brightest colors possible, with very few neutrals or grays. While yielding a very lively painting, the scheme makes creating a focal point (or area of interest) a challenge, as all the colors compete for attention.

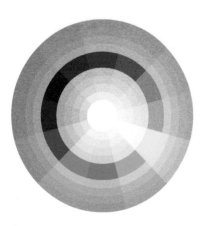

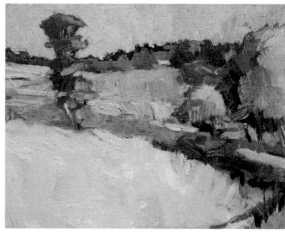

North Carolina Fields by Patti Mollica. Acrylic.

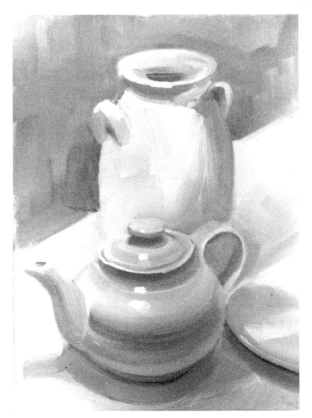

NEUTRAL SCHEME

As the opposite of the saturated scheme, the neutral scheme uses colors that have been grayed down. This diffused palette is perfect for foggy landscapes, white-on-white subjects, and scenes with a soft, mellow mood.

White Teapot by Patti Mollica. Acrylic.

SATURATED & NEUTRAL SCHEME

A scheme of this nature pairs highly saturated colors with various shades of gray. Because much of what we see in life is actually some form of gray, this scheme is often the most accurate way to depict color.

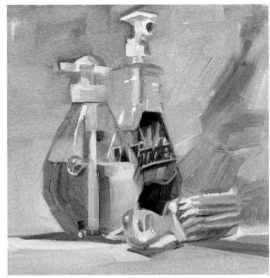

Blues Brothers by Patti Mollica. Acrylic.

COLOR & COMPOSITION

Color plays an integral role in how the eye moves throughout a painting. On the following pages, learn how to use it to guide the eye to a focal point and minimize visual competition to create an effective composition.

VALUE CONTRAST

An area of dark value next to a passage of light value commands the viewer's attention. Many painters will place the lightest color next to the darkest color within the focal point, such as the white highlight on the dark blue bottle.

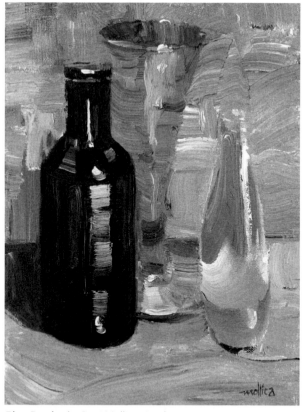

Blue Bottles by Patti Mollica. Acrylic.

EDGE CONTRAST

The edges between subjects (or shapes of color) in your painting can range from hard and crisp to soft and blurry. Because the eye is drawn to crisp edges, you can guide the viewer to your focal point by strategically softening and hardening your edges. In this non-representational piece, the focal point is in the lower right quadrant, where the crisp circular edges contrast the softer color changes and strokes of the rest of the painting.

Delta by Patti Mollica. Acrylic.

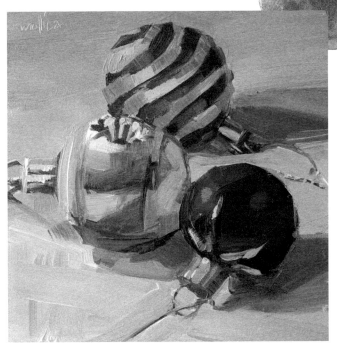

CHROMA CONTRAST

An area of bright, saturated color will naturally demand the viewer's attention when surrounded by less intense colors. In this painting, the high-chroma red and green of the ornaments "pop" against the gray background.

Shirley's Bulb by Patti Mollica. Acrylic.

TEMPERATURE CONTRAST

Maximum color contrast occurs when you place complementary colors next to each other within a painting. Because complements involve two colors opposite each other on the color wheel (one from the cool half and one from the warm half), the colors contrast in temperature. You can easily create a focal point by applying a warm color in a painting that is predominantly cool, or vice versa. Note that complementary colors of the same intensity will compete and vibrate, therefore it's best to desaturate one of them. In this painting, the warm, bright red contrasts effectively against the cooler, more muted greens.

Red Spot by Patti Mollica. Acrylic.

ATMOSPHERIC PERSPECTIVE

As artists, we are magicians and deceivers; at least that's what we *should* be. We are trying to convince the viewer that a two-dimensional image (our painting) is three-dimensional (our subject). To achieve this goal, we need to simulate depth and distance in our paintings. Generally speaking, the farther away things are, the more the effects of the atmosphere become apparent. Particles in the air interfere with our perception, which causes loss of contrast, detail, and focus. Referred to by Leonardo DaVinci as the "perspective of disappearance," this phenomenon is known today as "atmospheric (or aerial) perspective." According to this principle, objects take on a cooler, blue-gray middle value as they recede into the distance. What does that mean to us as watercolor artists? Here are a few color notes to remember in planning a painting:

Distant Objects
1. Colors are muted and less intense.
2. Colors are cooler.
3. Colors tend to be bluer, grayer, and have more middle values.
4. There is less contrast.
5. Shadows are paler.
6. Detail is minimized.

Close Objects
1. Colors are brighter and more intense.
2. Colors are warmer.
3. Colors have lighter lights and darker darks.
4. There is more contrast.
5. Shadows are deeper, richer, and have more color.
6. Detail is maximized.

In addition to using color, we can enhance and even force this perception of space and distance by paying particular attention to the following visual cues:

Size *Objects in the distance appear smaller than objects in the foreground.*

One-Point Perspective *Vertical and horizontal lines appear closer together as they move toward the horizon.*

Overlapping *Placing objects in front of other objects will help produce the illusion of distance.*

Detail *Objects in the distance have less detail and appear subtler than closer objects.*

Focus *Objects that are far away appear slightly out of focus.*

Temperature *Foreground objects are warmer in tone. As objects recede, they become cooler.*

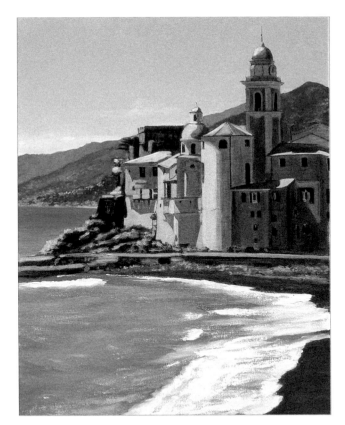

In this coastal painting, artist Tom Swimm gives the elements in the foreground (the sunlit building and the rocks along the shore) the brightest, warmest colors, keeping them sharp in focus with more detail. He uses increasingly less detail for the hills and rocks along the distant shore, also applying more subtle, cooler colors as he moves into the background.

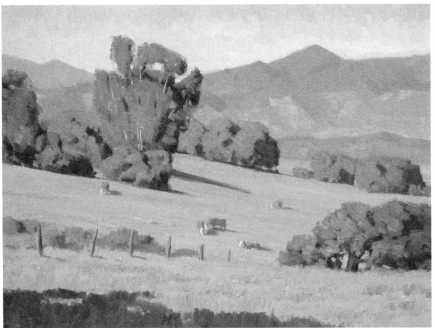

Artist Frank Serrano creates a sense of depth in this oil painting by using muted colors for the most distant areas while accenting the closer foreground areas with bright orange and blue-violet wildflowers.

INFUSING COLOR

A scene or photo reference may have an interesting composition or value pattern but uninteresting colors. As an artist, you can take matters into your own hands and infuse color where it does not (yet) exist. In the two examples on this page, see how an artist brings life into a scene with some improvised color. As discussed on pages 16–18, establishing the correct values is the most important factor in creating a readable subject—then you are free to colorize as you please!

Artist Joseph Stoddard uses a palette of playful colors to turn a distant urban scene into a lively cityscape in watercolor.

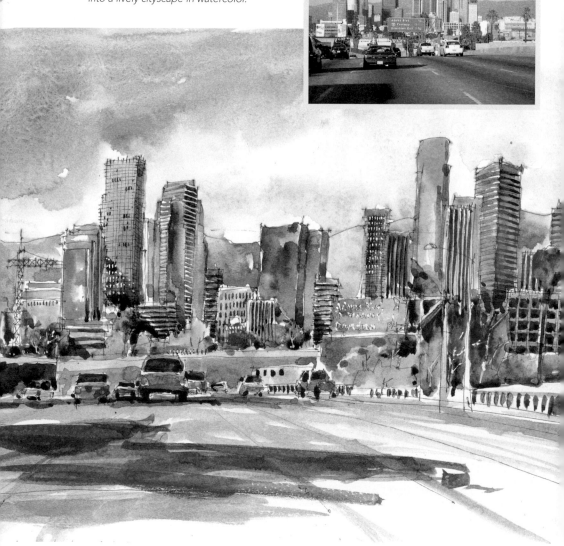

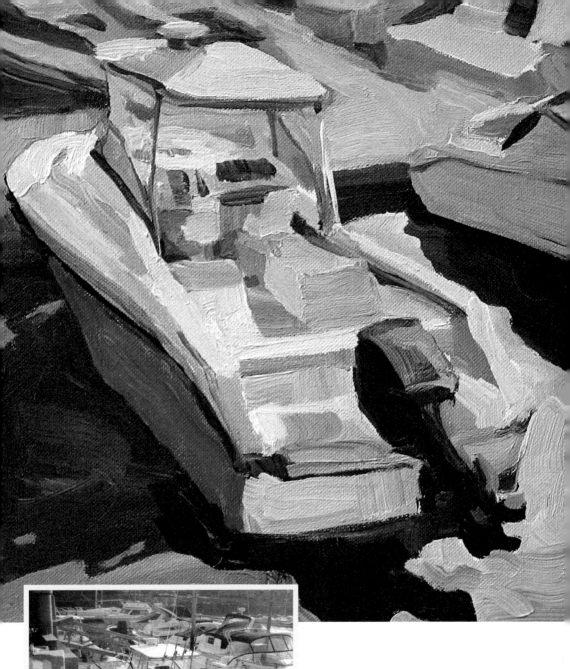

Rye Marina Boat by Patti Mollica. Acrylic

Artist Patti Mollica uses a beautiful acrylic palette of pinks, purples, and blue-greens to bring color into a gray-dominated boat scene.

Chapter 2:
Pigments

Pigments are the particles that give art media their color. Made from ground minerals or manufactured compounds, pigments have been valued for their use in fine art and traded throughout history. In the last century, there has been considerable scientific progress in pigment manufacturing, giving artists a large and exciting collection to work with. Today, it's important how various pigments behave and interact to gain insight into effective color use. This chapter covers the following:

- A History of Paint
- Pigment Safety
- Pigment Properties
- Pigment Quality Chart

Pigment Properties

In various art media, pigment (in powdered form) is held together by a binder, such as oil, acrylic polymer, or gum arabic. The pigments are evenly distributed and suspended (not dissolved) in the binder. The binder, in tandem with other ingredients, determines the style and flow of the medium onto a drawing or painting surface. However, the pigment itself has specific qualities that allow for interesting variations—from a pigment's opacity to its ability to stain and tint. Learn about the most important properties that distinguish pigments, and use the chart on pages 50–51 as a consolidated reference.

PIGMENT BINDERS

MEDIUM/ART TOOL	BINDER
Watercolor paint	Gum arabic
Gouache paint	Gum arabic
Acrylic paint	Acrylic polymer dispersion
Oil paint	Oil (such as linseed)
Colored pencil	Wax or kaolin clay
Soft pastel	Methyl cellulose, gum arabic, or gum tragacanth
Oil pastel	Oil and wax

PAINT TOXICITY

Some paint colors contain toxic metals, so it's important to handle them with care. Limit contact with your skin and eyes, and avoid inhaling or ingesting them. Below are a few paints with toxicity levels that call for consideration as you paint, with the offending ingredients in parentheses. Remember: If a paint name contains the word "hue," it is most likely a nontoxic substitute for the original pigment.

- Cadmium red, yellow, and orange (cadmium)
- Cerulean blue (cobalt)
- Chrome green, yellow, and orange (chromates and/or lead)
- Cobalt blue, green, violet, or yellow (cobalt)
- Emerald or Paris green (copper acetoarsenite)
- Flake white (lead)
- Manganese blue and violet (manganese)
- Naples yellow (lead and antimony)
- Vermilion (mercury)
- Zinc sulfide white (zinc sulfide)
- Zinc yellow (chromate)

A HISTORY OF PAINT

The very first "paint" was made from charcoal or earth pigments such as limonite, hematite, red ochre, yellow ochre, umber, burnt bones, and white calcite, which was then ground up into a paste and mixed with binders of spit, blood, urine, vegetable juices, or animal fat. Humans applied this paint using twigs, feathers, or animal hair—often they even blew the paint through hollow bones to produce an "airbrush" effect.

The Greeks and Romans discovered the use of wax, resin, and eggs as a binding vehicle, while the Egyptians discovered and used earth pigments. The Middle Ages brought the discovery of ultramarine (blue), which was used extensively in representations of the Virgin Mary's garments as a symbol of purity. By the 15th century, walnut and linseed oil began to replace egg as a binder, paving the way for a far more versatile medium: oil paint. This ushered in a new era of advancements in an artist's ability to depict realism in perspective, picture-plane depth, luminosity, enhanced color, and more nuanced simulations of light and shadow.

The 19th century, which marked the beginning of the Modern Age, brought both the inventions of watercolor and the collapsible tin paint tube, revolutionizing the painting world and leading to a new era of color. No longer bound by grinding their own pigments, artists founded color-based movements such as Impressionism and Fauvism. Simultaneously, new and more vivid pigments burst onto the scene as a reaction to this new era of color liberation. The Contemporary Age, starting in 1900, brought artists the invention of both water-based paint (acrylics) and synthetic pigments, touted for their unparalleled brilliance of hue, lightfastness, and translucency.

Today artists have access to both tried-and-true mediums and new advancements in the art world. What a fabulous time to be an artist!

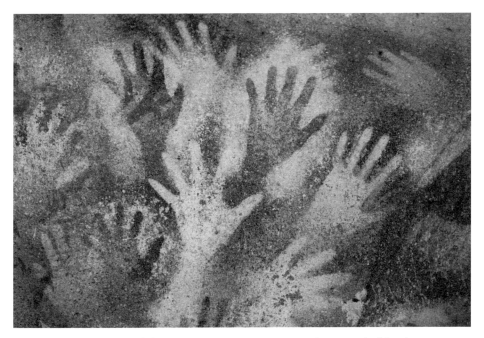

Ancient Paintings *Cueva de los Manos in Patagonia, Argentina, features colorful and lively ancient cave paintings that date between 9,500 and 13,000 years old. Many of the hands are stenciled, suggesting the use of an airbrush technique.*

INORGANIC VS. ORGANIC

There are two basic pigment types: inorganic and organic. Inorganic pigments come from the earth or are manufactured from non-carbon substances. These include earth pigments such as yellow ochre and burnt umber. Synthetic organic pigments are laboratory-created carbon compounds. Sometimes called "modern" pigments, they are often more intense than inorganic pigments. Many of them display beautiful transparency and promising lightfastness (resistance to fading) qualities.

Inorganic pigments:

- Alizarin crimson
- Burnt umber
- Prussian blue
- Raw umber
- Ultramarine blue
- Yellow ochre

Organic pigments:

- Azo yellow
- Hansa yellow
- Perylenes
- Phthalocyanines
- Pyrroles
- Quinacridones

PIGMENT OPACITY

Pigments are characterized as either transparent or semi-transparent, semi-opaque, or opaque. Opaque pigments more effectively block light from hitting the substrate or surface beneath, whereas transparent pigments allow light to pass through and reflect the substrate back to the viewer. Opaques provide more coverage and appear to advance toward the viewer, so they are better suited for foreground objects and highlights. Transparents create luminous and atmospheric effects in paintings and are great for suggesting depth in shadows. Transparents also make wonderful glazes.

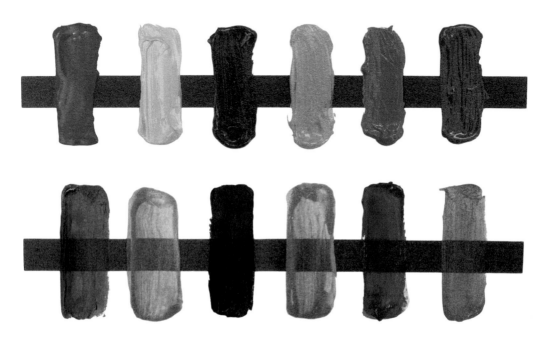

Here you can view highly opaque pigments (top row) versus highly transparent pigments (bottom row). To know the qualities of the pigments in your own palette, it's a good idea to create a chart like this with your paints. Simply paint a stroke over a black line (such as permanent marker) on your painting surface.

STAINING VS. NONSTAINING

Pigments are classified as staining or nonstaining. Staining pigments, such as alizarin crimson or the phthalocyanines, immediately absorb into the paper's surface and are impossible to lift or dab away completely. Nonstaining pigments, such as burnt umber or the cadmiums, sit on the surface of the paper and lift away easily. This pigment quality is most relevant to watercolor, particularly when working with techniques that call for dabbing away the pigment. If you want to use staining colors but need the ability to lift them away, you can apply watercolor lifting preparation medium to your paper before applying paint, which makes lifting possible with any pigment.

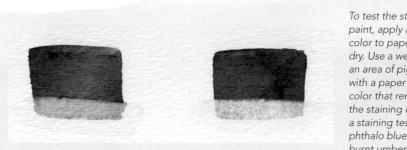

To test the staining quality of a paint, apply a rich stroke of the color to paper and allow it to dry. Use a wet brush to loosen an area of pigment and dab with a paper towel. The more color that remains, the higher the staining quality. Above is a staining test performed with phthalo blue (staining) and burnt umber (nonstaining).

TINTING

When using pigments with a strong tinting quality, a little goes a long way. Knowing the tint strength is helpful when mixing colors; strong paints can overpower those with weak tinting strength, so you will have to adjust your mixes accordingly. Many highly tinting pigments are also highly staining.

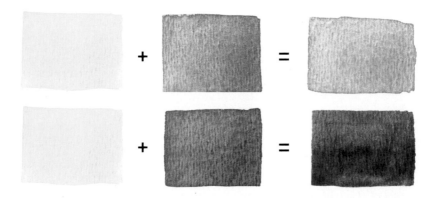

In this example, see how a highly tinting pigment can overpower a pigment of lesser tinting strength. The top row shows lemon yellow mixed with cobalt blue in equal parts (both moderate in tinting strength), which yields a soft green. The bottom row shows lemon yellow mixed with phthalo blue in equal parts. Phthalo blue, a highly tinting pigment, clearly dominates the mix.

MASSTONE VS. UNDERTONE

When assessing a paint, artists often refer to its masstone and undertone. Masstone is the paint as it appears in a thick scoop from the tube, whereas undertone is the paint as it appears thinly over a white support. A pigment's masstone and undertone can vary quite a bit in hue and value.

Permanent rose (acrylic)

Phthalo green (acrylic)

LIGHTFASTNESS

Lightfastness refers to the ability of pigment to resist fading over time, particularly when exposed to UV light. Lightfast pigments are not prone to fading and are considered to be more permanent than nonlightfast pigments. Nonlightfast—or fugitive—pigments lighten and lose their intensity quicker. The American Society for Testing and Materials (ASTM) has developed a rating system for lightfastness; a paint's rating is visible on its tube. It is measured on a scale of I to V, with I and II being the only acceptable ratings for professional artists.

PAINT VARIATION

Manufacturers offer "hue" varieties of popular paint colors—especially in student-grade paint lines. A hue is not made purely of the pigment specified in the name; instead, it is a mixture of other pigments to match the hue of the original. Manufacturers often do this to reduce cost or toxicity. Paint names, formulations, and properties may also vary between manufacturers; for this reason, many artists are loyal to one brand of paints.

Pigment Quality Chart

Swatch	Paint/Pigment Name	Color	Pigment Type	Transparency	Staining Ability	Lightfastness (ASTM)
REDS						
●	Alizarin crimson	blue-leaning red	organic	transparent	high	II or III
●	Cadmium red	yellow-leaning red	inorganic	opaque	low	I
●	Quinacridone red	blue-leaning red	synthetic organic	transparent	high	I
●	Naphthol red	yellow-leaning red	synthetic organic	semi-opaque	high	I
●	Perylene red	slightly blue-leaning red	synthetic organic	transparent	medium	I
●	Pyrrole red	yellow-leaning red	synthetic organic	semi-opaque	high	I
PURPLES						
●	Dioxazine purple	blue-leaning violet	synthetic organic	transparent	high	I
●	Quinacridone violet / Quinacridone magenta	red-leaning violet	synthetic organic	transparent	medium	I
BLUES						
●	Ultramarine blue	red-leaning blue	inorganic	semi-transparent	low	I
●	Phthalo blue	yellow-leaning or red-leaning	synthetic organic	transparent	high	I
●	Manganese blue	yellow-leaning blue	inorganic	transparent	high	I
●	Cobalt blue	slightly yellow-leaning blue	inorganic	semi-transparent	low	I
●	Cerulean blue	yellow-leaning blue	inorganic	semi-transparent	low	I
GREENS						
●	Phthalo green	blue-leaning green	synthetic organic	transparent	high	I
●	Cobalt green	yellow-leaning green	inorganic	semi-transparent	low	I
●	Terre verte	olive green	inorganic	transparent	low	I
●	Viridian	blue-leaning green	inorganic	transparent	low	I

Swatch	Paint/Pigment Name	Color	Pigment Type	Transparency	Staining Ability	Lightfastness (ASTM)
YELLOWS						
	Aureolin	primary yellow	inorganic	transparent	low	II
	Hansa yellow / Lemon yellow	bright blue-leaning yellow	synthetic organic	semi-transparent	low to medium	II
	Nickel azo yellow	brownish yellow	synthetic organic	transparent	medium	I
	Cadmium yellow	red-leaning yellow	inorganic	opaque	low	I
EARTH COLORS						
	Burnt sienna	red-leaning brown	inorganic	transparent	low	I
	Burnt umber	red-leaning brown	inorganic	transparent	low	I
	Raw sienna	yellow-leaning brown	inorganic	transparent	low	I
	Raw umber	varied; often gray- or green-leaning brown	inorganic	transparent	low	I
	Yellow ochre	orange-leaning yellow	inorganic	opaque	low	I
BLACKS						
	Ivory or bone black	warm black	inorganic	semi-transparent	high	I
	Mars black	cool black	inorganic	opaque	high	I
WHITES						
	Titanium white	blue-leaning white	inorganic	opaque	N/A	I
	Zinc white / Chinese white	blue-leaning white	inorganic	semi-opaque	N/A	I

Note: The colored circles shown are for illustrative purposes only. Actual paint colors may not match exactly due to variations in printing ink.

Chapter 3:

Color Mixing

With a foundational understanding of pigments in place, you can move on to the art of paint mixing. Although basic guidelines are helpful to consider as you mix, there is plenty room for personal preference and style. You'll also find that mixing acrylic and oil is a very different process than mixing watercolor. This chapter covers the following topics:

- Basic Painting Materials
- Mixing Oil & Acrylic
- Mixing Watercolor
- Color Mixes for Watercolor
- Color Mixes for Oil & Acrylic

Basic Painting Materials

To fully grasp the way pigments behave and interact, it's important to know the basics of your media. On the following pages, you'll find information on the tools and materials needed to experiment effectively with color through paint.

TYPES OF PAINT

• **Watercolor:** Watercolor is a water-based paint made of pigment, gum arabic, glycerin, and a humectant to keep the paint moist. Thin the paint with water to create fluid washes of color. The more water added to a mix, the lighter the paint will appear. Clean up watercolor with soap and water. For information on watercolor palettes and mixing, see page 60.

• **Acrylic:** Acrylic is also a water-based paint made of pigment and acrylic polymer dispersion. Thin it with water if desired, or paint in thick strokes. Acrylic can be used with a number of mediums and additives that change the consistency and sheen of the paint. Clean up acrylic with soap and water. For information on acrylic palettes and mixing, see page 56.

• **Oil:** This medium consists of pigments suspended in oil, such as linseed oil. This slow-drying paint is thick and luminous. Because oil paints are not water-based, they require a solvent for thinning the paint and cleaning up. Note that solvent emits toxic fumes, is highly flammable, and must be disposed of safely and legally. For information on oil paint palettes and mixing, see page 56.

INTERFERENCE ACRYLIC PAINT

One of the most innovative new paints on the market is interference paint. When painted over a dark background, the interference color will appear and shimmer. When painted over a light-colored background, its complementary color will appear. Because these paints are not technically pigments, you can mix them with any color.

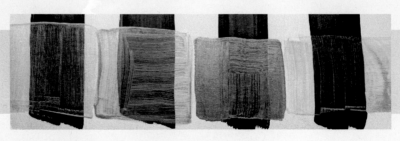

BRUSHES

Choosing the right brush for the right task makes a big difference in your painting experience. Brushes come in three basic types: soft natural-hair, soft synthetic-hair, and bristle.

- **Soft natural-hair brushes:** These brushes are made of the hair of an animal such as a weasel, badger, or squirrel. High-quality naturals hold a good amount of moisture and are ideal for watercolor.

- **Soft natural-hair brushes:** These brushes are made of man-made fibers such as nylon and polyester. They are durable and ideal for acrylics, but they can be used with watercolor as well when natural-hair brushes are cost prohibitive.

- **Bristle brushes:** These brushes have coarse and sturdy bristles for working with thick oil and acrylic paint. They produce visible painterly brushstrokes. Made of hog hair, the bristle ends are flagged (or split) so they can hold more hair.

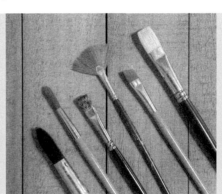

Shown are a variety of brush shapes, from round and flat to fan. Each shape produces a different style of stroke. Note that brush handles vary in length; short handles are best for watercolor and detail work, whereas long handles are best for painting with an easel while working in acrylic and oil.

SUPPORTS

A support is the surface on which you paint. Watercolor artists generally use sturdy papers coated with sizing, which prevents the paper from absorbing too much moisture and buckling or tearing. The paper comes in hot-press (smooth), cold-press (irregular), and rough textures. Acrylic artists can use a variety of supports, from canvas and wood to wood composite board and sturdy paper. Oil paint is generally used on canvas or wood. Before applying acrylic or oil to your support, make sure it has been primed so the paint has a bright, toothy surface to which it can bond. Many artists today prime their supports with white acrylic "gesso."

OTHER SUPPLIES

- Jars of water for mixing and cleanup
- Paper towels and rags
- Old clothes or an apron
- Solvent for cleanup (if using oil paints)
- Artist tape and clips for securing your support to a painting surface
- Spray bottle for keeping watercolor and acrylic paints moist during a painting session

Mixing Oil & Acrylic

MIXING PALETTES FOR OILS & ACRYLIC

Mixing palettes are surfaces for preparing and mixing paints. They come in a wide variety of materials, shapes, and sizes. Below are the most readily available palettes for oil and acrylic painters.

Wooden Palettes Traditional wooden palettes offer a flat, lightweight mixing surface for oil paints. The wood color provides a warm middle value to help you better judge your paint values as you mix—particularly if you paint on toned surfaces. These palettes often have a thumbhole to make it easy to hold while painting. Before using a wooden palette, seal its surface with a few layers of linseed oil or shellac. To clean, scrape off the paint and wipe down with a cloth and solvent. Note that wooden palettes are not a good choice for acrylic paint, which dries quickly and adheres to the wood.

Plastic Palettes White plastic palettes are smooth, lightweight, and inexpensive mixing surfaces. They are available in an assortment of sizes and shapes, including handheld and tabletop varieties. Some are simple and flat, whereas others feature shallow wells for mixing washes. If using acrylic, clean the palette with soap and warm water. If using oil, clean it with a cloth and solvent.

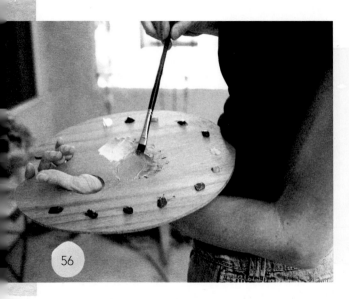

TIP

In addition to a surface for mixing paints, the term "palette" can refer to the selection of paint colors you use to create a work. For example, Fauvist painters such as Matisse often used bold and bright palettes to represent their subjects.

Clear Palettes *Sheets of plexiglass or tempered glass make excellent tabletop mixing surfaces for oil or acrylic. They are sturdy, smooth, and easy to wipe clean. To control the color or value of the surface, paint the underside or slip a sheet of toned paper beneath. You can tape the edges for safer handling.*

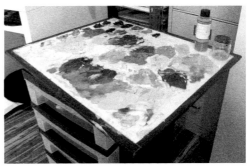

Palette Paper *Palette paper comes in pads of disposable sheets. The paper is poly-coated for a smooth, moisture-resistant surface. Work directly on the pad and tear off the sheet when finished, or begin by placing a clean sheet on a flat surface (such as an old baking sheet).*

Sealed Trays *Many artists use shallow, airtight containers for storing their palettes. You can use the plastic bottom directly, but most use them in conjunction with paper or handheld palettes. If using oil, this tray will protect the paint from dust. If using acrylic, this tray will help the paint stay moist if sealed and stored with a wet sponge. There are a few "stay wet" palettes for acrylic on the market that come with a sponge component.*

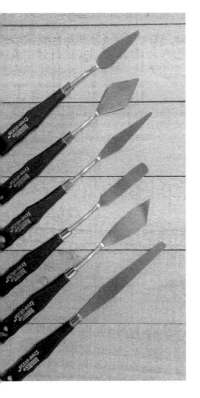

PALETTE KNIVES

Although you can mix small amounts of acrylic and oil on your palette with a brush, it's more efficient to use a palette knife for mixing large quantities. This handheld tool has a thin, flexible metal blade that you can use to scoop, smash, and move paint on your palette. A painting knife is similar to a palette knife, but it has a neck that sets the blade away from the handle. This prevents your hand from accidentally smearing your painting as you work. Painting knives offer interesting ways to apply (or remove) paint from your painting surface—from thick impasto strokes to thin smears and scraped designs.

Painting Knife Shapes *Painting knife blades are available in a wide range of sizes and shapes, such as diamond, trowel, pointed, and angled. Choose the best shape for the effects you desire. Palette and painting knives are also available in plastic for an affordable and disposable option.*

Mixing Acrylics with a Palette Knife

Step 1
Begin by using the knife to pick up the paint colors you'd like to mix. Place them next to each other in an open area on your palette.

Step 2
Think of the mixing process as scoop, smash, and pat. Holding the blade at an angle to the mixing surface, scoop the paint piles onto the knife.

Step 3
Turn over the palette knife and smash the paint onto the palette. Then gently pat and smear the pile of paint, spreading the paint colors into each other. Scoop and repeat this step until the paint is mixed to your liking.

Step 4
Spreading the mix flat on your surface will help you judge the value of the paint without any shadows or strong highlights.

Step 5
Leaving as much paint on the palette as possible, finish by wiping off the blade using a paper towel or cloth. Some artists prefer lint-free rags for this step.

GLAZING ACRYLICS

Another way to mix acrylic paint is to do so directly on your painting surface in thin layers called "glazes." You can create glazes by thinning acrylic with water or a medium specifically designed for glazing. Before applying a glaze over an existing color, make sure the existing paint is completely dry. Glazes not only create new and luminous tones on the canvas, they can also serve to unify a scene with washes of subtle color.

Creating a Glazing Chart

Using the colors in your palette, it's a good idea to create a glazing chart similar to the example below. This will show you how each color looks when glazed under or over the other colors. In this glazing chart, the horizontal strokes of color were applied first, and the vertical columns of color were glazed on top.

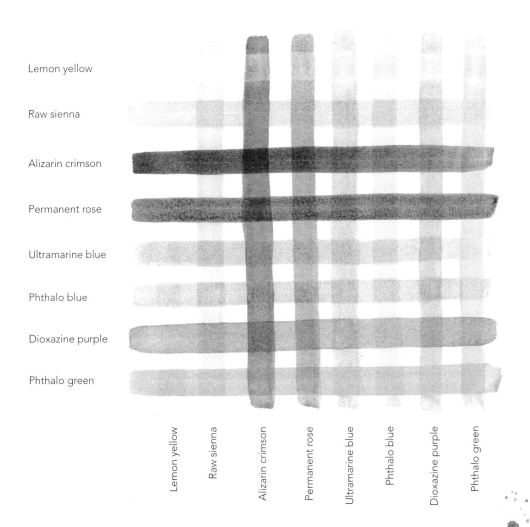

Lemon yellow

Raw sienna

Alizarin crimson

Permanent rose

Ultramarine blue

Phthalo blue

Dioxazine purple

Phthalo green

Lemon yellow · Raw sienna · Alizarin crimson · Permanent rose · Ultramarine blue · Phthalo blue · Dioxazine purple · Phthalo green

Mixing Watercolor

MIXING PALETTES FOR WATERCOLOR

Watercolor palettes are often made of white plastic, aluminum, tin, or ceramic (such as porcelain). These surfaces wipe clean easily and provide a bright mixing surface, allowing artists to judge the intensity of their watercolor washes. Watercolor palettes feature varying sizes of wells or pots that allow the washes to pool. Below are the most common formats available, although old shallow dishes found around the house can work as well.

Simple Welled Palette *These palettes feature circular or rectangular mixing wells. Rectangular wells are generally slanted for better pooling. These types of palettes are great to use for one painting session at a time; clean them completely after each use.*

Travel Palettes *These portable, compact palettes conveniently fold and snap shut for painting on the go. The smaller wells can hold pan paints or wet paint straight from the tube, and the larger wells are great for mixing. You can let the tube paint dry in the small wells, reactivating the paint with water when needed.*

Potted Palettes *These palettes come with a number of lidded pots that line mixing wells. The pots keep water-based paints—such as watercolor, gouache, and acrylic—moist and ready to mix. They also prevent spilling during travel.*

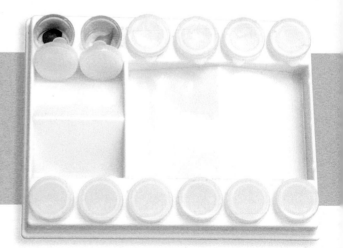

APPROACHES TO WATERCOLOR MIXING

Painting with fluid, transparent washes of watercolor is a unique and enjoyable experience because of the way the colors can be mixed. Other types of paint (especially oil) are usually mixed on a separate palette and then applied to the canvas. They are also mixed *additionally*; in other words, white pigment is added to lighten the colors. In contrast, watercolor relies on the white of the paper and the translucency of the pigment to communicate light and brightness. A well-painted watercolor seems to glow with an inner illumination that no other medium can replicate. One way to make your painting vibrant and full of energy is to mix most of your colors on paper. It is unpredictable to a certain degree, but if your values and composition are under control, these unexpected color areas will be exciting and successful.

WET ON DRY

This method involves applying different washes of color on dry watercolor paper and allowing the colors to intermingle, creating interesting edges and blends.

Mixing in the Palette vs. Mixing Wet on Dry To experience the difference between mixing in the palette and mixing on paper, create two purple shadow samples. Mix ultramarine blue and alizarin crimson in your palette until you get a rich purple; then paint a swatch on dry watercolor paper. Next, paint a swatch of ultramarine blue on dry watercolor paper. While still wet, add alizarin crimson to the lower part of the blue wash, and watch the colors connect and blend. Observe the added energy of the colors mixing and moving on the paper versus the flat wash.

Variegated Wash

A variegated wash differs from the wet-on-dry technique in that wet washes of color are applied to wet paper instead of dry paper. The results are similar, but using wet paper creates a smoother blend of color.

Applying a Variegated Wash After applying clear water to your paper, stroke on a wash of ultramarine blue. Immediately add some alizarin crimson, and then tilt to blend the colors. Compare this to your wet-on-dry swatch to see the subtle differences caused by the initial wash of water on the paper.

WET INTO WET

This technique is like the variegated wash, but the paper must be thoroughly soaked with water before you apply any color. The saturated paper allows the color to spread quickly, easily, and softly across the paper. The delicate, feathery blends created by this technique are perfect for painting skies.

Creating a Wet-into-Wet Wash
Loosely wet the area you want to paint. After the water soaks in, follow up with another layer of water and wait again for a matte sheen to appear. Then apply ultramarine blue to your paper, both to the wet and dry areas of the paper. Now add a different blue, such as cerulean, and leave some paper areas white. Now add some raw sienna and a touch of alizarin crimson. The wet areas of the paper will yield smooth, blended, light washes, while the dry areas will allow for a darker, hard-edged expression of paint.

CHARGING IN COLOR

This technique involves adding pure, intense color to a more diluted wash that has just been applied. The moisture in the wash will grab the new color and pull it in, creating irregular edges and shapes of blended color.

Creating a Charged-In Wash
Apply a wash of phthalo blue; then load your brush with pure burnt sienna and apply it to the bottom of the swatch. Follow up with pure new gamboge at the top, and watch the pigments react on the paper.

GLAZING WATERCOLORS

Glazing is a traditional watercolor technique that involves two or more washes of color applied in layers to create a luminous, atmospheric effect. Glazing unifies the painting by providing an overall wash of consistent color.

Creating a Glaze *To create a glazed wash, paint a layer of ultramarine blue on your paper (which can be either wet or dry). After the wash dries completely, apply a wash of alizarin crimson over it. The subtly mottled purple that results is made up of individual glazes of transparent color.*

Creating a Glazing Chart

Using the colors in your palette, it's a good idea to create a glazing chart similar to the example below. This will show you how each color looks when glazed under or over the other colors. You'll notice that transparent colors such as phthalocyanines, rather than granulating opaques such as cerulean blue, create smoother, more luminous glazes. In this glazing chart, the vertical columns of color were applied first, and the horizontal strokes of color were glazed on top.

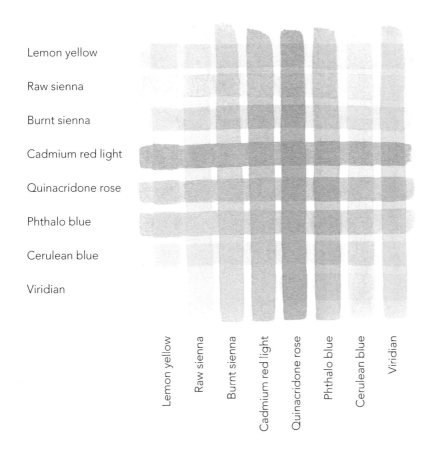

Lemon yellow

Raw sienna

Burnt sienna

Cadmium red light

Quinacridone rose

Phthalo blue

Cerulean blue

Viridian

Lemon yellow · Raw sienna · Burnt sienna · Cadmium red light · Quinacridone rose · Phthalo blue · Cerulean blue · Viridian

Color Mixes for Watercolor

As we discussed on pages 61–63, watercolor can be mixed either on the palette or on the paper to yield different effects. For clarity of color, this section features mixes created on the palette and applied to paper. As you experiment with color mixing, remember that it's best to limit your mixes to two or three pigments—any more than this can easily produce muddy results.

BASIC WATERCOLOR PALETTE

A basic watercolor palette generally includes a warm and cool version of each primary color, plus a few neutrals and sometimes a black. Artists often mix secondary colors rather than clutter their palette with additional paints. However, because green is such a predominant color in landscape painting, it may be helpful to include a green paint or two as well. The palette below features viridian, which can be replaced by the more intense phthalo green if desired. The mixes in this section use the colors listed in this palette.

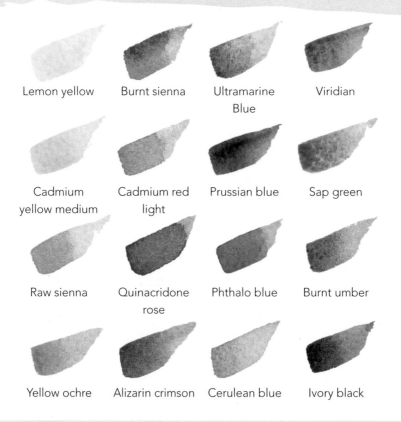

Lemon yellow	Burnt sienna	Ultramarine Blue	Viridian
Cadmium yellow medium	Cadmium red light	Prussian blue	Sap green
Raw sienna	Quinacridone rose	Phthalo blue	Burnt umber
Yellow ochre	Alizarin crimson	Cerulean blue	Ivory black

TIP

Some of the mixes that follow contain the same pigments, but different proportions lead to different results. Experiment with ratios to find your desired hue.

MIXING PURPLES

Purples appear in everything from florals and sunsets to distant mountains. It is easy to mix vibrant purples using a red-leaning blue and a blue-leaning red, but a variety of neutral purples are also very useful for creating depth in a painting through subtle shadows and distant layers of a landscape.

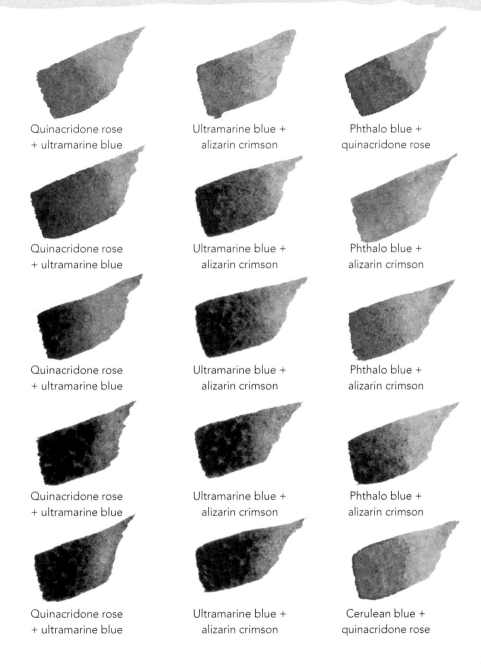

Quinacridone rose + ultramarine blue	Ultramarine blue + alizarin crimson	Phthalo blue + quinacridone rose
Quinacridone rose + ultramarine blue	Ultramarine blue + alizarin crimson	Phthalo blue + alizarin crimson
Quinacridone rose + ultramarine blue	Ultramarine blue + alizarin crimson	Phthalo blue + alizarin crimson
Quinacridone rose + ultramarine blue	Ultramarine blue + alizarin crimson	Phthalo blue + alizarin crimson
Quinacridone rose + ultramarine blue	Ultramarine blue + alizarin crimson	Cerulean blue + quinacridone rose

MIXING GREENS

It's likely that you'll mix more greens than any other color, especially if you paint landscapes. These tones are ubiquitous in nature and range from bright, sunlit yellow-greens to soothing, muted tints and shades. You'll find that the most vibrant greens result from combining a yellow-leaning blue with a blue-leaning yellow. The mixes on these pages also provide a wide selection of neutral greens, as well as rich tones and glowing highlights so you can capture the dynamic variations that exist within foliage.

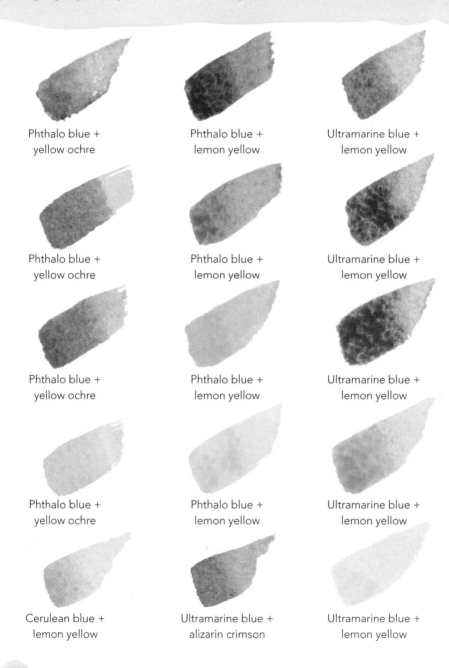

Phthalo blue +
yellow ochre

Phthalo blue +
lemon yellow

Ultramarine blue +
lemon yellow

Phthalo blue +
yellow ochre

Phthalo blue +
lemon yellow

Ultramarine blue +
lemon yellow

Phthalo blue +
yellow ochre

Phthalo blue +
lemon yellow

Ultramarine blue +
lemon yellow

Phthalo blue +
yellow ochre

Phthalo blue +
lemon yellow

Ultramarine blue +
lemon yellow

Cerulean blue +
lemon yellow

Ultramarine blue +
alizarin crimson

Ultramarine blue +
lemon yellow

Prussian blue +
yellow ochre

Prussian blue +
burnt sienna

Phthalo blue +
burnt sienna

Prussian blue +
yellow ochre

Cerulean blue +
yellow ochre

Ultramarine blue +
alizarin crimson

Prussian blue +
yellow ochre

Viridian +
alizarin crimson

Ultramarine blue +
alizarin crimson

Prussian blue +
yellow ochre

Prussian blue +
yellow ochre

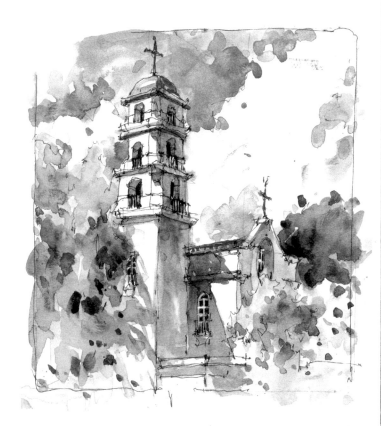

In this watercolor painting, artist Joseph Stoddard builds depth in his foliage by avoiding large, flat washes of green. Instead, he applies a variety of green strokes—from bright gold tones to deep blue-greens.

MIXING ORANGES

From dramatic skies to sunlit accents, orange can easily play a dominant or a supporting role in a painting. Vibrant oranges result from red-leaning yellows mixed with yellow-leaning reds, but soft, neutral oranges are useful for warming up a painting without overwhelming the eye.

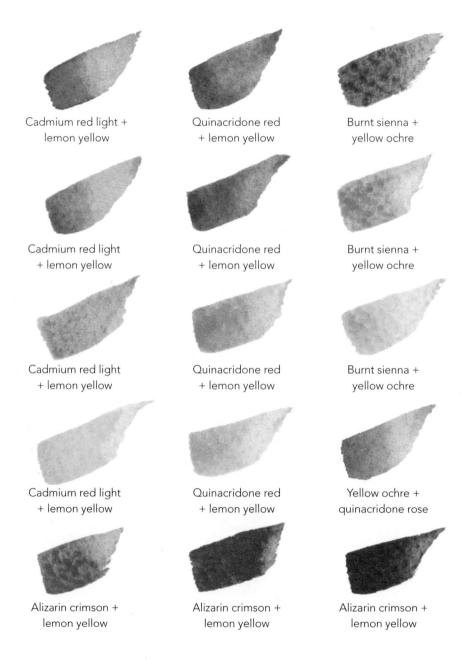

Cadmium red light + lemon yellow	Quinacridone red + lemon yellow	Burnt sienna + yellow ochre
Cadmium red light + lemon yellow	Quinacridone red + lemon yellow	Burnt sienna + yellow ochre
Cadmium red light + lemon yellow	Quinacridone red + lemon yellow	Burnt sienna + yellow ochre
Cadmium red light + lemon yellow	Quinacridone red + lemon yellow	Yellow ochre + quinacridone rose
Alizarin crimson + lemon yellow	Alizarin crimson + lemon yellow	Alizarin crimson + lemon yellow

MIXING NEUTRALS

Neutrals may not hold a spot on the basic color wheel, but they are essential for painting realistically. Look around, and you'll see that the world is dominated by neutral tones—from cool blue-grays to violet-leaning browns. It is these more subtle colors that allow purer colors to "sing" in a painting.

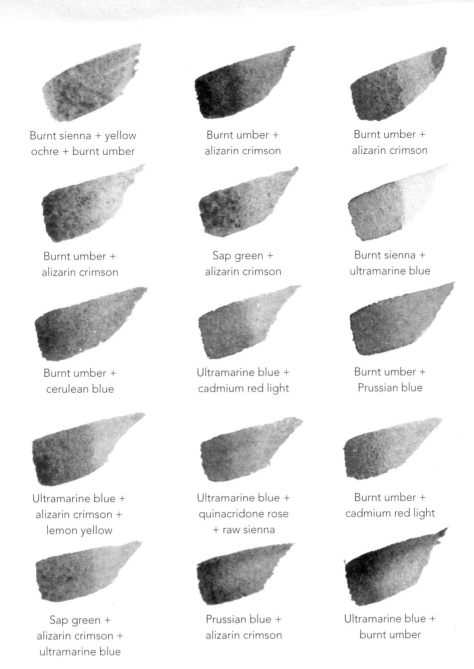

Burnt sienna + yellow ochre + burnt umber

Burnt umber + alizarin crimson

Burnt umber + alizarin crimson

Burnt umber + alizarin crimson

Sap green + alizarin crimson

Burnt sienna + ultramarine blue

Burnt umber + cerulean blue

Ultramarine blue + cadmium red light

Burnt umber + Prussian blue

Ultramarine blue + alizarin crimson + lemon yellow

Ultramarine blue + quinacridone rose + raw sienna

Burnt umber + cadmium red light

Sap green + alizarin crimson + ultramarine blue

Prussian blue + alizarin crimson

Ultramarine blue + burnt umber

Color Mixes for Oil & Acrylic
Samples of Violet Mixes

Below is a selection of mixes that are helpful when working with violets. Each mix is accompanied by a "recipe," allowing you to re-create any swatch desired.

1 part quinacridone magenta +
1 part cobalt violet +
1 part white

1 part white +
1 part cobalt violet

2 parts white +
1 part dioxazine purple

2 parts cobalt violet +
1 part cadmium red medium +
1 part white

2 parts phthalo blue +
1 part medium violet +
1 part white

2 parts white +
2 parts dioxazine purple +
1 part ultramarine blue

2 parts white +
1 part dioxazine purple +
1 part ultramarine blue

1 part quinacridone magenta +
1 part white

2 parts cobalt violet +
1 part cadmium red medium

2 parts cobalt violet +
2 parts white +
1 part cadmium red medium

1 part quinacridone magenta +
1 part phthalo blue

2 parts phthalo blue +
1 part dioxazine purple +
1 part white

SAMPLES OF BLUE MIXES

Below is a selection of mixes that are helpful when working with blues. Each mix is accompanied by a "recipe," allowing you to re-create any swatch desired.

2 parts white +
1 part ultramarine blue

2 parts white +
1 part ultramarine blue +
1 part cobalt violet

1 part ultramarine blue +
3 parts white

1 part ultramarine blue +
1 part white

1 part white +
1 part ultramarine blue +
1 part cobalt violet

1 part ultramarine blue +
1 part cobalt violet +
4 parts white

2 parts white +
1 part phthalo blue

1 part white +
1 part phthalo blue

3 parts white +
1 part phthalo blue

2 parts white +
1 part ultramarine blue +
1 part cobalt violet

1 part white +
1 part phthalo blue +
1 part dioxazine purple

2 parts white +
1 part phthalo blue +
1 part dioxazine purple

SAMPLES OF GREEN MIXES

Below is a selection of mixes that are helpful when working with greens. Each mix is accompanied by a "recipe," allowing you to re-create any swatch desired.

3 parts white +
1 part phthalo green

1 part phthalo green +
3 parts white +
2 parts lemon yellow

2 parts cadmium yellow dark +
2 parts white +
1 part phthalo green

2 parts white +
1 part phthalo green

1 part lemon yellow +
1 part white +
1 part phthalo green

1 part cadmium yellow dark +
1 part phthalo green

1 part white +
1 part phthalo green

2 parts lemon yellow +
1 part white +
1 part phthalo green

1 part cadmium yellow dark +
1 part phthalo green

1 part white +
1 part phthalo green +
2 parts ultramarine blue

2 parts lemon yellow +
2 parts phthalo green +
1 part ultramarine blue

1 part cadmium yellow dark +
1 part phthalo green +
1 part ultramarine blue

SAMPLES OF ORANGE MIXES

Below is a selection of mixes that are helpful when working with oranges. Each mix is accompanied by a "recipe," allowing you to re-create any swatch desired.

3 parts white +
1 part cadmium orange

2 parts white +
1 part cadmium orange +
1 part lemon yellow

1 part cadmium orange +
1 part cadmium yellow medium

2 parts white +
1 part cadmium orange

2 parts white +
1 part cadmium yellow dark +
1 part cadmium orange

1 part cadmium yellow dark +
1 part cadmium orange

1 part cadmium orange +
1 part cadmium yellow medium +
1 part cadmium red medium

1 part cadmium orange +
1 part cadmium yellow medium +
1 part cadmium red medium +
1 part cobalt violet

1 part cadmium orange +
1 part cadmium yellow dark +
1 part cadmium red medium +
1 part cobalt violet

1 part cadmium yellow medium +
1 part cadmium red medium +
1 part cadmium orange

1 part cadmium orange +
1 part quinacridone magenta

1 part cadmium orange +
1 part crimson red +
trace of cobalt violet

SAMPLES OF BROWN MIXES

Below is a selection of mixes that are helpful when working with browns. Each mix is accompanied by a "recipe," allowing you to re-create any swatch desired.

3 parts yellow ochre +
1 part quinacridone magenta +
trace of dioxazine purple

2 parts yellow ochre +
1 part cadmium orange +
trace of dioxazine purple

1 part phthalo green +
4 parts cadmium orange

3 parts yellow ochre +
3 parts titanium white +
1 part quinacridone magenta +
trace of dioxazine purple

2 parts yellow ochre +
2 parts titanium white +
1 part cadmium orange +
trace of dioxazine purple

1 part phthalo green +
4 parts cadmium orange +
2 parts titanium white

3 parts cadmium orange +
1 part ultramarine blue

2 parts cadmium red medium +
1 part cadmium yellow dark +
trace of Payne's gray

2 parts lemon yellow +
1 part crimson +
1 part cerulean blue

3 parts cadmium orange +
1 part ultramarine blue +
2 parts titanium white

2 parts cadmium red medium +
3 parts titanium white +
1 part cadmium yellow dark +
trace of Payne's gray

2 parts lemon yellow +
1 part crimson +
1 part cerulean blue +
3 parts titanium white

SAMPLES OF GRAY MIXES

Below is a selection of mixes that are helpful when working with grays. Each mix is accompanied by a "recipe," allowing you to re-create any swatch desired.

1 part cadmium orange +
2 parts phthalo green +
10 parts white

1 part cadmium orange +
2 parts phthalo blue +
2 parts Payne's gray +
20 parts white

1 part Payne's gray +
1 part cobalt violet +
1 part white

1 part yellow ochre +
2 parts white +
trace of phthalo green

2 parts cerulean blue +
1 part cadmium orange +
10 parts white

1 part Payne's gray +
1 part cobalt violet +
10 parts white

2 parts phthalo blue +
2 parts cadmium orange +
20 parts white

2 parts cerulean blue +
1 part Payne's gray +
8 parts white

1 part ultramarine blue +
1 part ivory black +
10 parts white

1 part phthalo blue +
2 parts cadmium orange +
10 parts white

1 part cadmium orange +
1 part Payne's gray +
8 parts white

1 part cadmium red medium +
2 parts phthalo green +
3 parts white

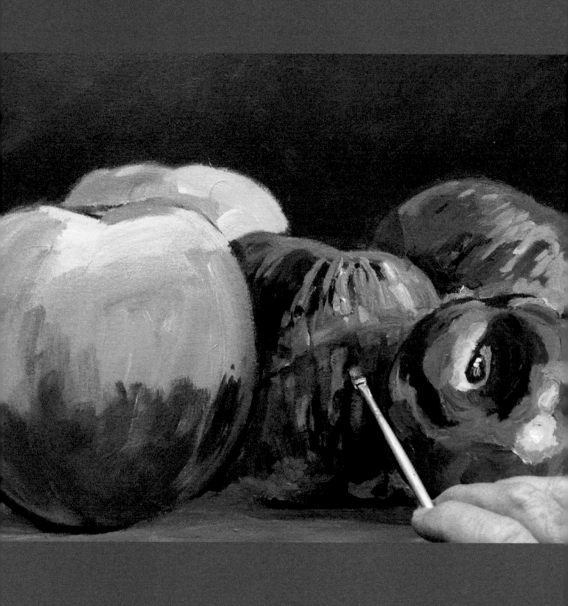

CHAPTER 4:
Painting Demonstrations

Now that you're equipped with color vocabulary, concept application, and mixing guidelines, it's time to try your hand at painting. In this group of step-by-step projects, you'll find a variety of styles, techniques, and processes presented by an accomplished selection of artists. This chapter features the following demonstrations:

- *Northern Lights* with Maury Aaseng (watercolor)
- *Goldfinch & Thistle* with Maury Aaseng (watercolor)
- *Tudor Hydrangea Garden* with David Lloyd Glover (acrylic)
- *Apples & Plums* with David Lloyd Glover (acrylic)
- *Watery Landscape* with Jan Murphy (oil)
- *Foothills* with Jan Murphy (oil)

Northern Lights

WATERCOLOR WITH MAURY AASENG

Dramatic clouds, moody gray skies, and beautiful sunsets are common backdrops to landscapes and outdoor scenes in watercolor. But one of the sky's most unforgettable scenes occurs when you find yourself far enough north and outdoors on a clear night. The aurora borealis is hauntingly beautiful, and its displays can frame a lakescape in an otherworldly light. The ethereal colors, dancing rays, and amorphous shapes make for an exciting watercolor challenge.

STEP ONE

This scene features the northern lights as seen from the edge of a lake, with the lights reflected in the calm water below. First, use a ruler and pencil to lightly draw a horizon line. Add droplets of masking fluid for the stars (see "Star Detail"). Then saturate your entire paper with clean water using a wide flat or wash brush. Then create a variegated wash of lemon yellow mixed with viridian to create light greens and alizarin crimson mixed with permanent rose for pinks. Use a large round brush loaded with paint to add the lightest greens at the horizon line, and paint "fingers" of darker green reaching outward and upward. Then add crimson between these areas and allow them to diffuse. Once dry, create a loose mirror image of the wash below in the lake. It doesn't have to be exact; simply follow the general patterns of color. It's easiest to mimic the pattern by turning your paper 90 degrees.

DETAIL

Star Detail In areas that will become sky, spatter droplets of masking fluid to represent clusters of stars. Dip an old toothbrush in masking fluid and run your finger along the bristles to scatter the tiny drops. You will later remove them to reveal the white of the paper.

STEP TWO

Once the paper has dried, re-wet the sky and add the darker hues. Use indigo with a bit of crimson for variety. Then use a smaller brush to paint the bottom edge of the green "fingers" to give them more form. Keep the dark values from flowing over the light values by working with small brushes, ensuring that the pigment does not diffuse further than desired. Paint with your art board tipped back toward the top of the sky, which helps the colors flow upward and keeps the brightest values clean along the horizon. Then create the subtle vertical streaks in the sky (see "Light Detail"). While the sky dries, use a pencil to lightly sketch the foreground boulder and log shapes. Then apply masking fluid around the borders of these shapes.

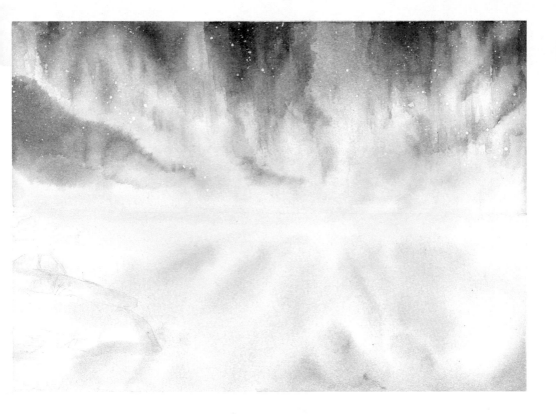

DETAIL

Light Detail As the wash just begins to dry, use a flat, synthetic brush to pull up from the horizon to create streams of light that flow upward. To pull out color where the pigment has gotten too dark, use a damp paper towel to press and pull upward. This creates a streaking effect as well.

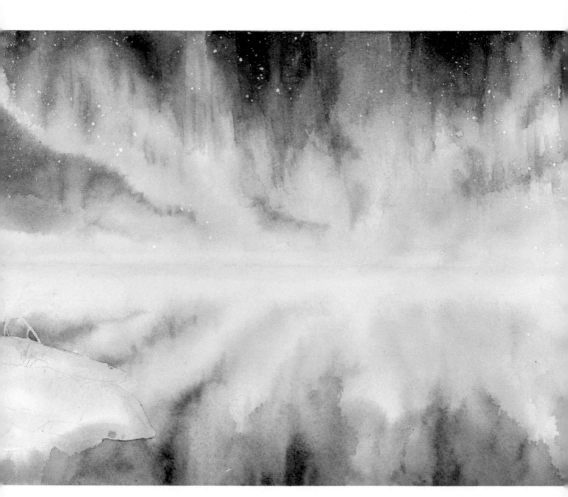

STEP THREE

Adding the dark values of the reflected sky is a simplified version of the previous step. Wet the area of reflection with a wide flat brush. Using indigo and crimson, paint the dark values so they match the general pattern of the sky above (dark blues at the bottom, light greens above). Water reflections rarely show the exact level of detail as the original object, so don't bother re-creating the same textures and streaks. Simply tilt your art board so the pigment and water flow downward. This still suggests the same direction of motion seen in the sky. Then allow your paper to dry.

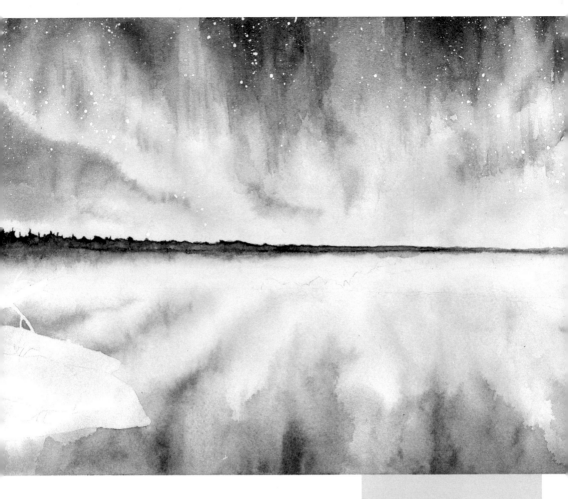

STEP FOUR

This step marks the point where the painting moves from an abstract study in color to a discernable landscape. Using an angled brush tipped with a heavy concentration of viridian, run it along the top of the horizon line. Let the brush "dance" just a little bit so it creates a rough edge to suggest the irregularity of a tree line on the distant shore. Since it is nighttime, darken the tip with indigo and repeat the process, allowing it to mix with the viridian.

To create the reflection of the shoreline, use a flat brush to wet the area below the horizon (water side). Run the brush along the horizon and allow the brush edge to touch the freshly painted tree line, allowing some wet paint to run down into the reflection. Darken along the horizon with indigo and viridian if desired.

DETAIL
Waterline Detail

Notice that some areas of the waterline are more pronounced (where the paint had dried), and others are blurred, where the pigment diffused into the trees. This variety creates a more natural appearance.

STEP FIVE

To paint the tree-covered peninsula in the middle ground, load a small angled brush with indigo and viridian. Sweep in the contours of the conifers, working from top to bottom. As you move downward, use more concentrated pigment for dark values, and let them intermingle with the shoreline. To vary the values, use a brush and clean water to touch areas of the painting, and dab out some areas of pigment. Brush in small areas of raw sienna and crimson to reflect some of the sky in the trees. Then use dark indigo and a liner brush to add the deepest values, such as the tree branches and rock cracks.

For the log and boulder, paint a variegated wash of Prussian blue, alizarin crimson, and viridian to create the values in the same color scheme as the aurora. Once partially dry, sprinkle sea salt onto the rock to move the pigment and create texture. Use dark indigo to brush shadows in the rocks. Dilute the indigo to brush shadows on the log, leaving the edges unshaded to give the impression of light reflecting off the log.

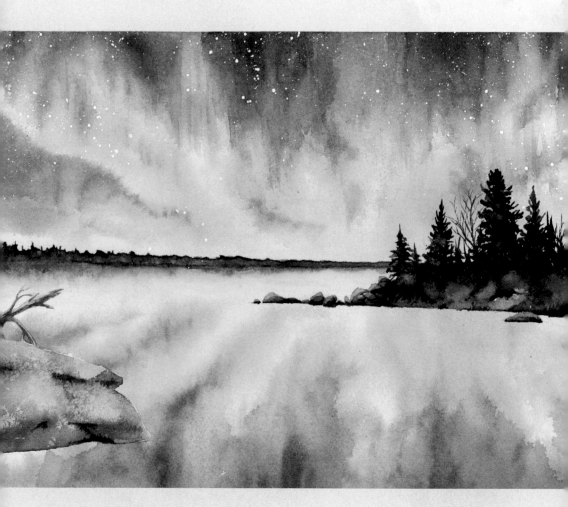

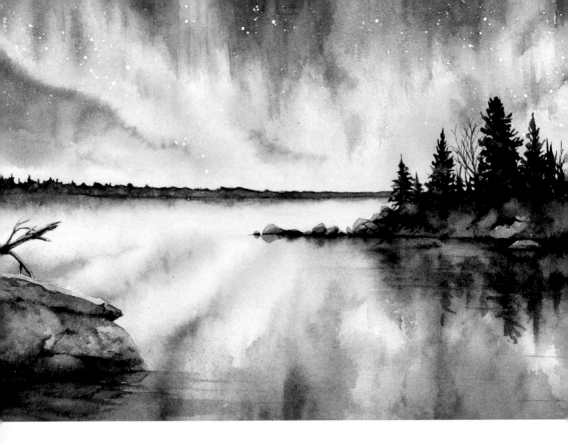

STEP SIX

Now add reflections of the rocks and trees. Use a flat brush to wet the area below the peninsula; then mirror the general shape of the trees and land, painting wet-on-wet and allowing the pigment to bleed outward. Once partially dry, use a small angled brush loaded with indigo to reflect the dark values of the peninsula. Then use the edge of a lightly dampened flat brush to wipe horizontal strokes across the reflection in a few areas, creating texture in the water.

Add another wash to darken values in the boulder, working around the highlights. Create the boulder's reflections, mimicking the general colors and values. Along the right edge of the boulder reflection, create jagged edges to suggest gentle motion in the water. Then run a damp angled brush horizontally through the reflection from left to right, pulling the color outward and twisting the brush for tapered points.

To finish, add the deepest darks. Use heavily concentrated indigo to paint the dark crevices in the rock, rock reflection, and log.

Goldfinch & Thistle

WATERCOLOR WITH MAURY AASENG

Thistle seed is a favorite food for goldfinches. When the birds perch in a natural stand of thistle flowers, their golden plumage appears to vibrate next to the complementary purple surroundings. Their regal black caps and black wing feathers create even more contrast, defining their petite bodies among the foliage. This project also incorporates blurred edges, loose textures, and painterly strokes to mimic the frenetic nature of goldfinch movements.

STEP ONE

To begin this painting, roughly sketch the composition to get a sense of the layout and relative values. Identify the highlights that you'll want to preserve—such as the white wing bars, feet, and beak—and apply masking fluid using the edge of a palette knife. Now wet your paper using a flat hog-hair brush, working irregularly but thoroughly dampening most areas. Create a variegated wash with sap green, raw umber, and lemon yellow for a yellow-green background. Let the paint disperse into the different colors. Add interest with subtle variations in texture (see "Texture Detail"), and brush in some mauve to create purple-pink hues that will tie in with the flower. Sop up any pools of water or heavy pigment with paper towel.

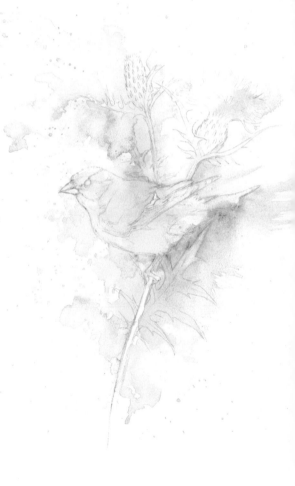

Details

Texture Detail To create interesting textures in your initial wash, spatter some paint on the left side of the paper, tapping a loaded brush with your finger (A). Also, use a dry hog-hair brush to pull some of the wet paint on the right edge of the page outward, creating visible brushstrokes (B). Touch painted areas of the paper using a brush loaded with clean water to make water blooms (C).

STEP TWO

The focus of this step is to create more value in the yellow hues of the bird. Once the initial wash dries, use a clean, fine round brush to dampen the yellow areas of the bird (avoiding the black wings, tail, and forehead) along with some of the background wash and stem of the plant. Apply lemon yellow and cadmium yellow to the body, using more cadmium for the shadow areas, and apply a thin cobalt blue to the feathers below the tail to suggest shadow. Use a small angled brush to paint raw umber in the darkest shadows, giving the feathers some definition. Finally, extend some background yellows downward along the stem of the plant, and tap your wet brush again to spatter for texture.

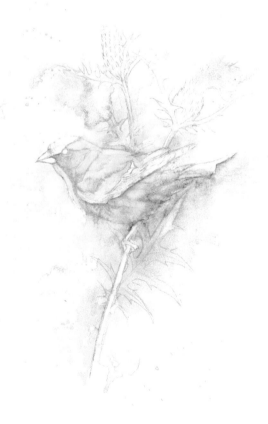

STEP THREE

Next, create more color definition in your thistle blossoms while maintaining a soft appearance. Brush clean water along the outer edge and a bit upward on the paper. While still damp, brush a mix of mauve and permanent rose along the base of the flower petals and let the color diffuse upward. In the large flower, use a small flat brush to paint the top in outward-moving strokes. The paint will diffuse and flow in the wettest areas. Lift some pigment away from the flower middle by dabbing with a paper towel. Return to the goldfinch and define the wing, cap, tail, and eye using a dark mix of ultramarine blue and burnt sienna. For areas of lighter value, use diluted burnt sienna. To tie some of your foreground colors in the background, use a hog-hair brush loaded with water to paint around the tail and wing, allowing water to touch the recently applied wet, dark paint. This allows the paint to flow naturally from the bird into the background. Once the paint dries, remove the masking fluid from the paper, revealing white highlights.

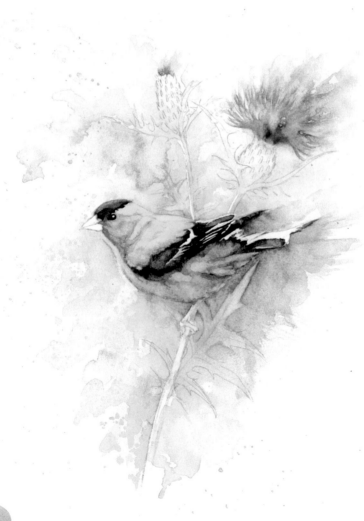

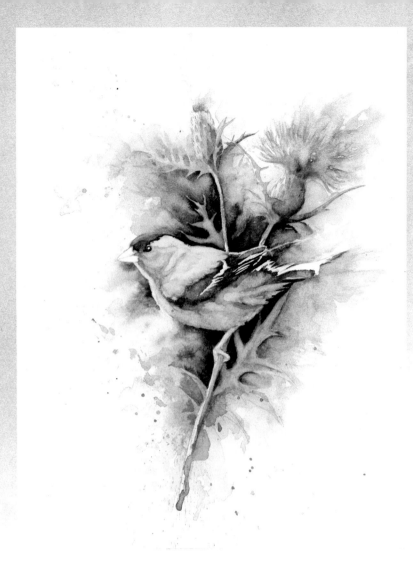

STEP FOUR

To contrast the brightness of the bird against the background, add sap green to the background, painting around the bird and filling in color on the thistle leaves and base of the flower. To soften the edges of the wash, brush clean water around the green. In other areas, such as the top of the painting, let some sharp corners of green remain to suggest the shapes of the thistle leaves. Spatter paint at the base of the image for a more painterly look. While the sap green is still damp, add heavily concentrated ultramarine blue around the bird, keeping it near the center of the composition. Soften the edges with water where necessary. Avoid encasing the subject matter entirely with a dark value; let the highlights of the subject matter "breathe" and interact with some corresponding highlights in the background, creating a more dynamic interaction.

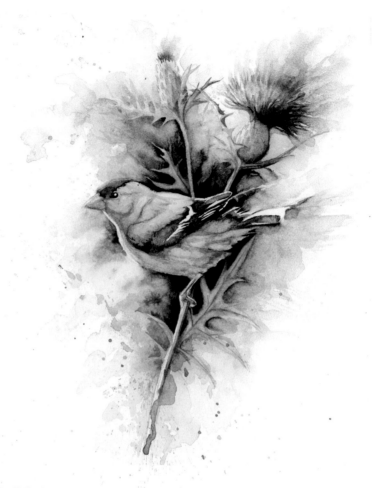

STEP FIVE

Returning to the flower, use concentrated mauve and permanent rose to brush in more concentrated pigment at the base of the flower petals. Blur the edges again by simply wiping them with a clean, damp brush. Make sure your darkest values are on the bottom right, creating volume without over-doing the detail. Next, add more detail in the goldfinch. Use a small, pointed brush to add cadmium orange as a base for the beak and leg. Leave some highlights unpainted around the foot and shin. If necessary, redefine some of the yellow feathers against the background using cadmium yellow and burnt sienna. To ground the bird a bit more, wet areas of the dark blue background along the edge of the bird (such as under the rump). This creates more subtle edges. You can also tie some of the background blue into the bird. Next, use a liner brush and concentrated sap green to sweep some fine detail along the leaf edges and veins.

STEP SIX

In this step, adjust the values of your background, shifting some of the darkness to the lower parts of the painting to achieve a more pleasing balance of visual weight. To lighten some upper areas, dampen and lift away pigment with a paper towel. Replace the color with diluted washes of sap green and mauve. To give weight to the bottom, apply more ultramarine blue. Then add final details to the bird, including the darkest values around the eye and between feathers. Apply these details sparingly. Deepen the values of the beak with orange and crimson, and extend these colors into the darkest shadows under the bird. Leave a bright patch of yellow along the chin and breast edge for a highlight. Next, add a bit of texture to the scaled flower base using ultramarine, suggesting the shadowed edges. To finish, make any final adjustments to the values and edges.

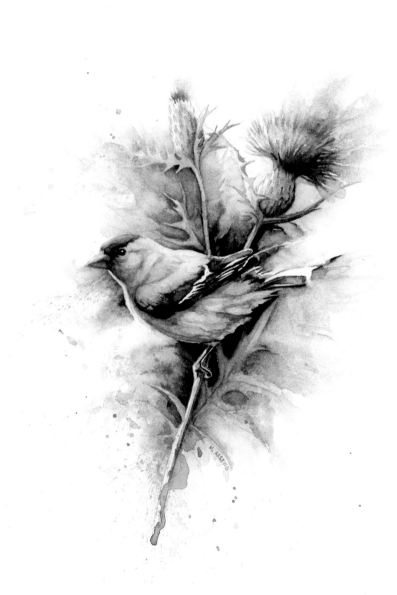

Tudor Hydrangea Garden
ACRYLIC WITH DAVID LLOYD GLOVER

A popular subject for painting in an impressionist style is an inviting garden patio in full bloom. Dappled sunlight on patio stones, a brick arch entrance with steps, and large, colorful pom-poms of hydrangea bushes are charming elements that offer artists the opportunity to work with vivid color palettes while exploring the interaction of color with light and shadow.

STEP ONE
Prepare a stretched 16" x 20" canvas with a wash of primary red. This will give your canvas ground a warm, pink hue that will subtly glow through in the final painting.

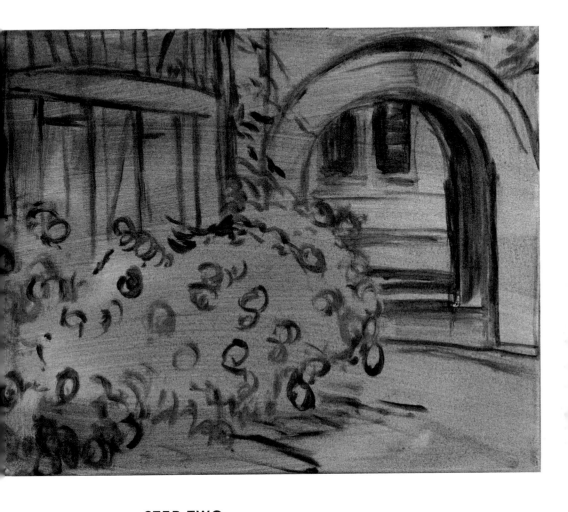

STEP TWO

For sketching in your scene, use thinned dioxazine purple to roughly suggest the key elements of the scene. Loosely indicate the shape of the archway, the steps, the positions of the hydrangea bushes.

STEP THREE

Start blocking in the base colors with bold strokes of color. To create the greens, blend phthalo blue with cadmium yellow light. For lighter greens, blend in titanium white. The base color of the bricks is cadmium yellow, cadmium red medium, titanium white, and dioxazine purple. The patio stone color is made up of ultramarine blue, cadmium yellow, and titanium white.

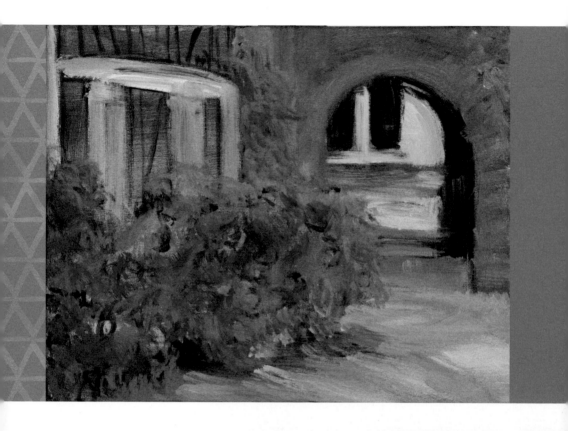

Details

Foliage Detail

Paint the foliage with short, curved brushstrokes that suggest the direction of the leaves.

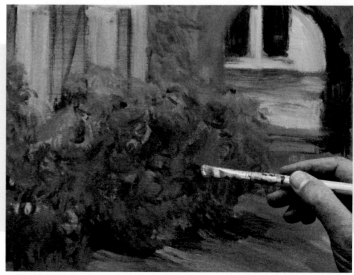

Detail

Stone Detail Establish the sunlit areas of the scene to create a sense of dimension. For the stone patio, use cadmium red light mixed with titanium white.

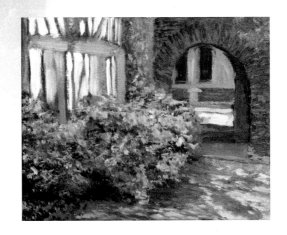

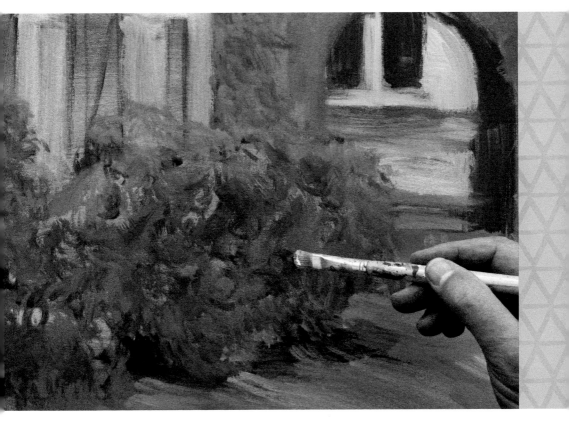

STEP FOUR

Create texture within the bricks using plenty of varied, broken brushstrokes. Use a variety of colors to create the impression of weathered brick. At this stage, the overall scene begins to emerge even though the brushwork is still rough and loose.

STEP FIVE

The details in the windows start to emerge with some finer brush detail. Layer the patio with more varied brushstrokes to build up the stone texture. Define the architectural details in the wall with blue-painted woodwork. Continue texturing the brick arch by building up layers of paint.

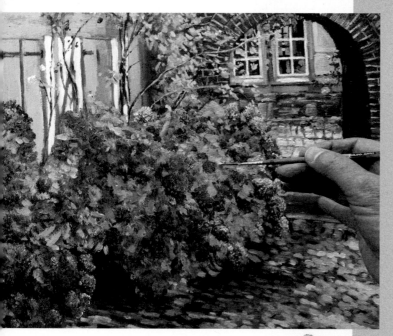

Details

Flower Detail With the foliage of the hydrangea bushes established, dab in the color blooms using a round bristle brush loaded with color. For the large pom-poms, mix a deep magenta with some titanium white on the brush. Paint the blooms in the shadow areas deeper and darker than the ones in light. The flowers in the sunlit areas should be brighter with more titanium white in the color mix. This will create the appearance of round, dimensional blooms.

STEP SIX

To finish the painting, place edges on some of the details. Note the long rose bush stems arching over the hydrangea bushes. Using the liner brush, paint highlights on the top edges to make them stand out. On the brick arch, use the liner brush to make a light color from cadmium yellow dark and titanium white. Lightly suggest the bricks with the outlines of mortar, careful not to overemphasize the lines. The accurate colors, textures, deep shadows, midtones, and highlights give the painting an overall realistic look, but the style should feel suggestive and painterly.

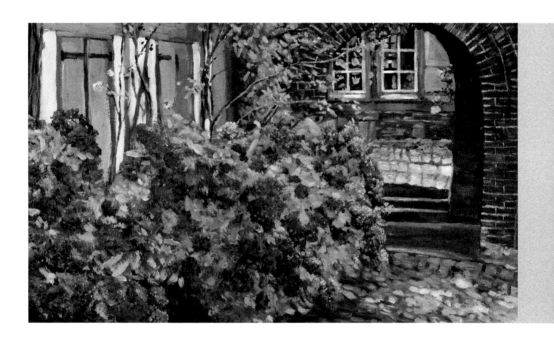

TIP

Before putting away your paints and brushes, always perform a final check of your proportions. You can do this easily by turning the canvas upside down on the easel. Take a step back to view the painting, and any corrections that need to be made should be obvious to your eye.

Apples & Plums

ACRYLIC WITH DAVID LLOYD GLOVER

Still life paintings (or paintings of inanimate objects in pleasing arrangements) offer an excellent way to sharpen your artistic skills. You can practice developing form, texture, and color tones in a single focused composition. This simple scene from a farm stand contains large, freshly picked summer orchard apples and luscious plums that feature lively color reflections.

STEP ONE

Prepare a stretched 16" x 20" canvas with a light wash of cadmium red light. This gives the canvas ground a warm, orange hue that will glow through the finished painting.

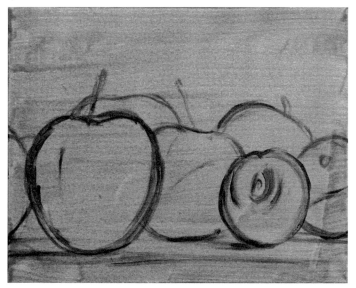

STEP TWO

Loosely brush in your sketch with thinned dioxazine purple. Draw the basic shapes of the fruits, establishing their placement relative to one another.

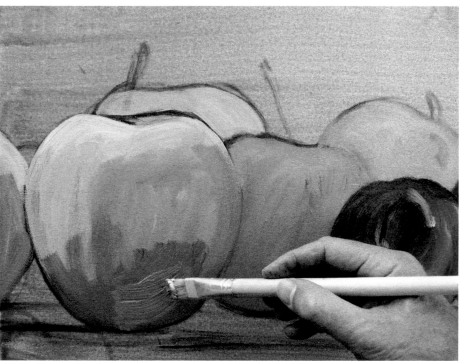

STEP THREE

Using both phthalo and ultramarine blue, block in the shapes of the plums. Color blocking helps establish an immediate visual relationship between each piece of fruit. Follow the contours of the apples and plums to give shape to each one. While color blocking, don't focus too much on color accuracy. Acrylic paint gives artists the flexibility to color correct throughout the painting process.

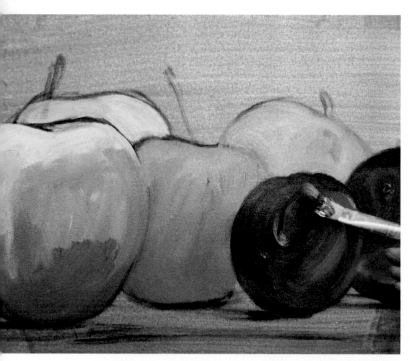

Detail

Apple and Plum Details When blocking in each base color, lay your brushstrokes in a manner that follows the direction of the fruit's shape. This emphasizes form and gives your subject a three-dimensional quality. For the orange-toned base of the apple (as shown), use cadmium yellow blended with white and a touch of phthalo blue.

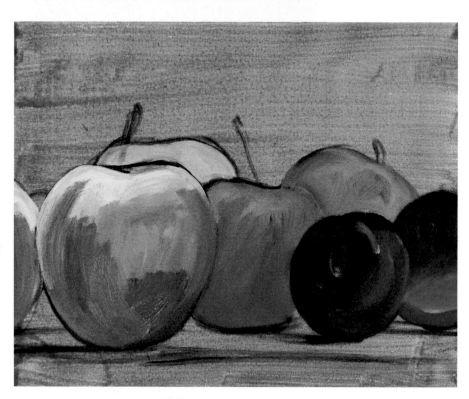

STEP FOUR

With a wide brush, stroke in the background tones using dioxazine purple and ultramarine blue brightened with a touch of white. The base color of the foreground table uses three tones of blue. Indicate the light source by blocking in the patterns of shadow. At this point, the still life composition has taken shape; the forms of the fruit have a natural dimension and weight.

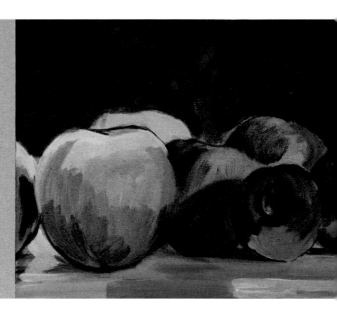

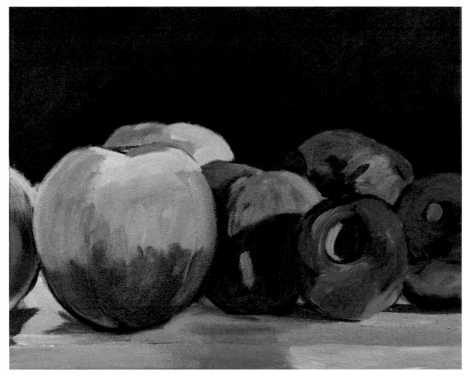

STEP FIVE

Now begin to refine the colors of the individual fruits. Tint your mixes with sufficient titanium white to mute the pure color. This will help the skin of the apples and plums appear luminous through the layers of color. Enhance the composition by keeping the direction of the light source evident.

Details

Skin Detail 1 Layer your tones the way they would appear on the naturally mottled skin of the apples. Because acrylic paint dries quickly and is permanent when dry, you can build depth of color easily by adding thin layers and glazes.

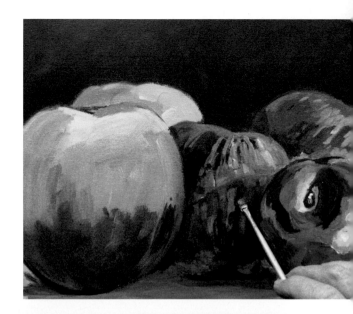

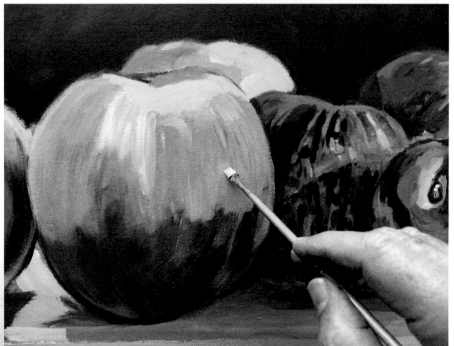

Skin Detail 2 Brighten your colors with titanium white and brush in the lightest tones of the apple skin. Like many apples, this skin is made up of many little specks of color. Imitate this quality by dabbing a variety of colors onto the surface, further giving the fruit shape and texture.

STEP SIX

Deepen the tones of the background to make it recede, which will visually push the fruit forward. Brighten the areas on the blue table that are in direct sunlight, making the edge of the table appear to be in the foreground. Note the colors of the green and red apples reflecting on the table's surface. The apple colors and table also reflect on the skin of the plum. The focal point of the piece is the apple with the cleanest edges, placing it up front and in focus; the other apples have softer edges, which subtly pushes them back further in the scene.

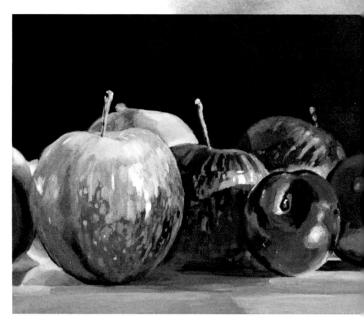

Detail

Stem Detail Bring sharpness to your focal point with details and well-defined edges. Use a fine liner brush to paint the brightest highlights, reflections, and edges of the apple stems. Keep the tones lively by using a variety of colorful details.

TIP

A still life has more energy when you leave visible brushstrokes. Overworking a painting can make it look stiff and static. Merely suggest the details, and the eye will fill in what you didn't paint.

Watery Landscape

OIL WITH JAN MURPHY

The term "atmospheric perspective" in art refers to creating the illusion of depth and dimension in your work. This phenomenon is responsible for the way objects in our field of vision appear to change in size, color, texture, focus, and even brightness as they recede into the distance. When applying it to your own art, paint distant objects with less detail using cooler, more muted colors, and paint foreground objects with sharper detail and brighter colors. In this painting, the distant mountains are muted with blues and violets, pushing them behind the warmer trees and shoreline. The sharper, thinner strokes of the water reflections make the water feel closer to the viewer.

STEP ONE

Use a wide flat brush to cover your canvas with a layer of yellow or yellow-orange paint. Don't worry about covering the canvas evenly. Once dry, add the base for the sky and water using mixes of blue and white. For the sky, use a lighter mix, and use a darker mix for the water. Again, these base layers do not need to be painted evenly. Some of the yellow will show through the layer of blue and give depth to your painting.

STEP TWO

Use a bristle brush to dab white, green, blue, and violet onto the canvas to build the mountains. Apply the paint liberally and scrub the paint with your brush to blend, working loosely and without detail as these mountains are far away. Remember that mountains appear to have a blue cast when viewed from a distance; use a downward stroking motion to create canyon areas in the mountains. Add more violet to create the illusion of shadows.

Detail

Mountain Detail Use more green paint at the bottom of the mountain range to create a closer hill in the middle ground, which adds to the sense of depth.

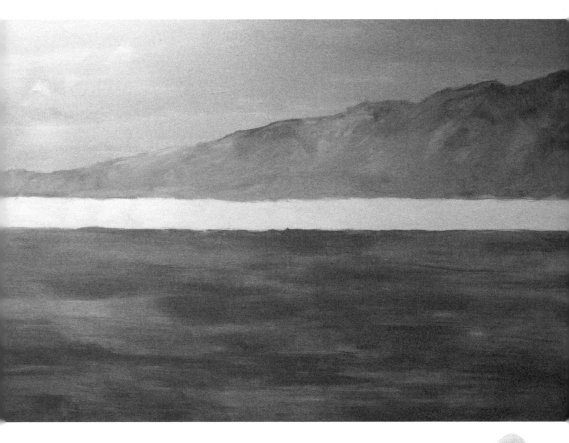

STEP THREE

Create a layer of clouds in the sky. They are not pure white, so place small amounts of violet and red on your palette. Use a clean brush to mix a tiny amount of violet into the white, and swirl your clouds onto the canvas sky. Place more clouds on the left side to balance the weight of the mountain range in the composition. Now blend a small amount of red into the white to continue building the clouds. Then blend them all with a dry brush or rag.

Next, use various shades of blue to develop the water. Note that the viewpoint of this painting is as though you are floating in the water, looking toward land. The water directly around you will have a semi-circular feel.

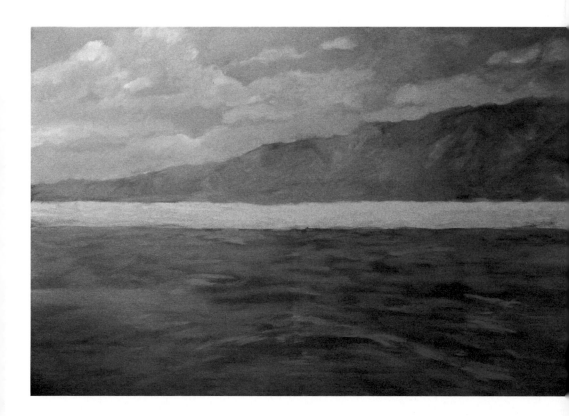

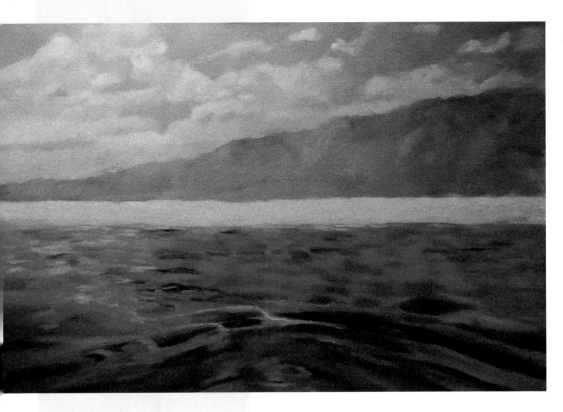

STEP FOUR

The water will reflect the colors of the sky. Because the water has calm waves, the reflection won't be a mirror image. Use the cloud colors within the water, and use some water colors within the sky; this will unify your painting. Also, add some turquoise and blue to your clouds for variation.

Detail

Cloud Detail You can purchase turquoise paint or mix it yourself. Experiment by mixing blue and green in varying amounts, adding white for lighter tints. Turquoise accents can help brighten up a sky.

STEP FIVE

Create a shoreline with trees and bushes using variations of green paint. Green's complementary color is red, so mix a bit of red with green to create the shadowed areas within the trees. To create highlights in the trees, add some yellow paint to the green and dab it on sparingly.

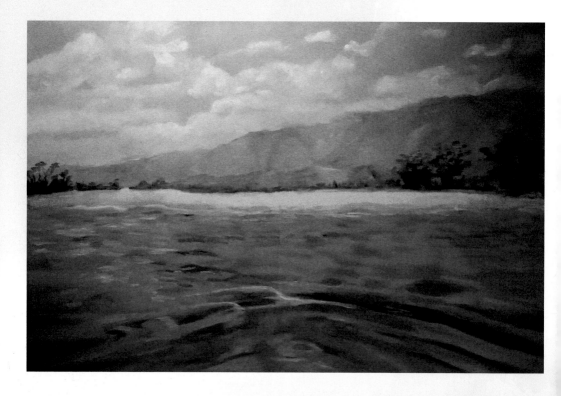

Detail

Middle Ground Detail

The middle ground should show more deliberate strokes than the background but not as much detail as the foreground.

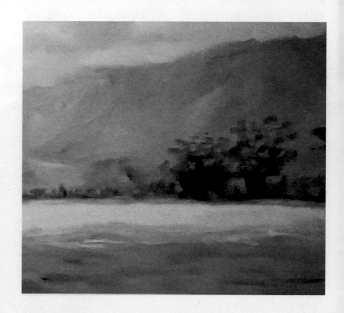

STEP SIX

Continue developing and softening the trees in the middle ground. Then add color in the clouds, water, and shoreline to add more "pop" and excitement to the scene. Applying multiple layers of paint will show depth and richness. Tie your painting together by adding some of the shoreline colors in the water reflections. Work a bit of yellow into the sky as well.

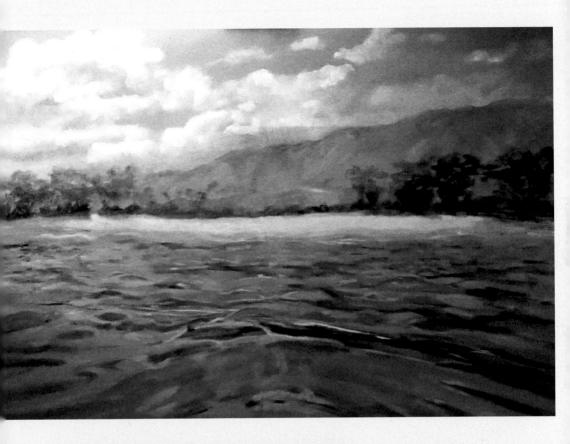

Detail

Water Detail

Let the shadows and color reflections define the rippled texture of the water's surface.

FOOTHILLS

OIL WITH JAN MURPHY

One approach to color in a painting involves muting the majority of your tones and allowing only a few areas of rich color to "pop" within the composition. This is particularly effective in a landscape, where wildflowers dot the landscape and act as areas of focus. In this scene, complementary colors blue and orange give the wildflowers even more energy and impact against the more subtle greens of the surrounding land.

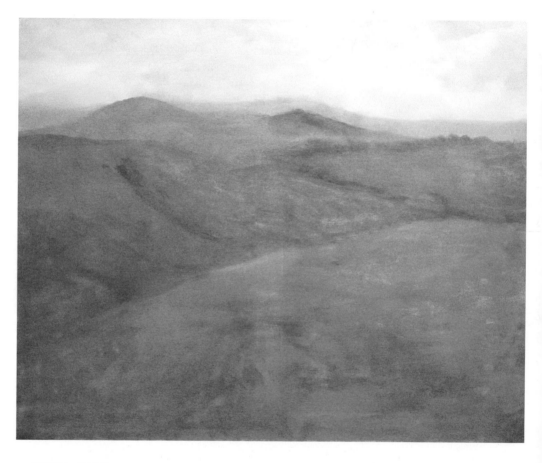

STEP ONE

Tone your canvas using a warm layer of yellow or yellow-orange oil paint and a wide flat brush. Cover the canvas loosely; it does not have to be even. This layer of color will peek through any layers you paint on top of it, giving the painting warmth and depth. Once dry, begin painting the receding foothills by blocking in the largest shapes. As the hills move into the distance, the colors will become lighter and bluer with hints of violet. Notice the warm canvas tone showing through.

STEP TWO

Once the paint is dry to the touch, add another layer of paint over the foreground hills, distant hills, and sky, building up value and refining shapes.

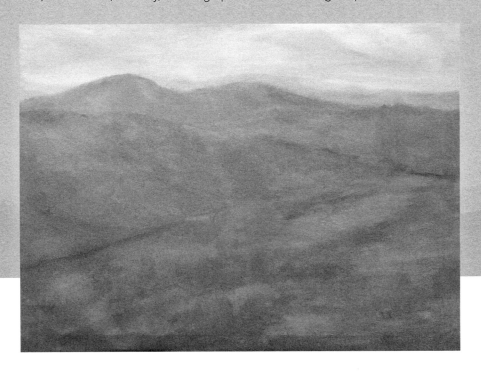

STEP THREE

Use greens to create trees and bushes in the middle ground. Vary your mixes of green by adding white and yellow to your green paint. Dab the paint on the canvas with a bristle brush, keeping your strokes soft.

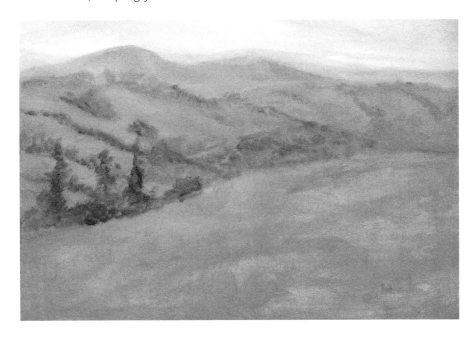

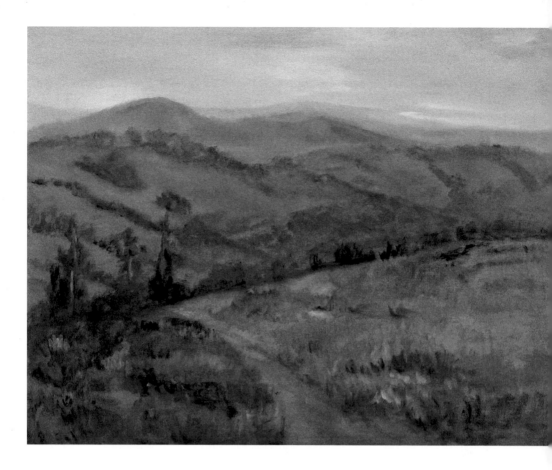

STEP FOUR

Now add wildflowers to the foreground using loose brushstrokes and blue-violets, golds, reds, and yellows. These flowers should have the purest colors in the canvas to make them "pop" against the rest of the landscape. Add a path from the bottom of the canvas leading to the trees, which will help draw the viewer's eye into the composition.

Detail

Wildflower Detail As you paint the wildflowers, the goal is to show broad areas of color. Avoid painting all the details of the flowers, and stick to subtly suggesting the textures with loose brushstrokes.

STEP FIVE

Use blue, violet, white, and green to develop the hills in the distance. This is a good time to refine the shapes of the hills. Be certain to paint the farthest hills with lighter blues. Now add layers to your clouds. As you stroke, try to retain some of the yellow-orange color in the sky; this will help tie the colors together in your painting.

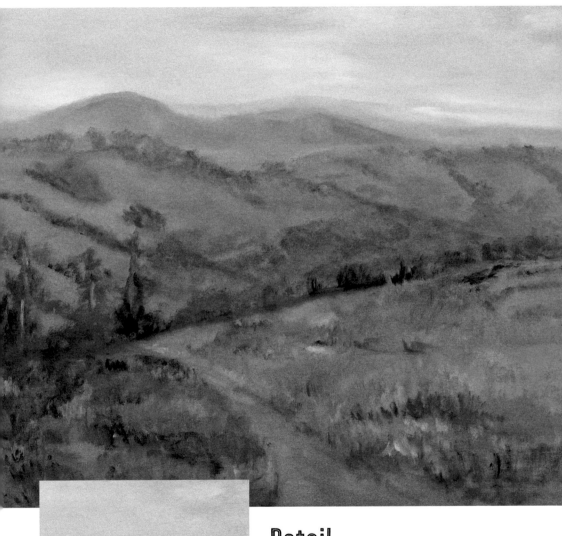

Detail

Distant Mountain Detail Next time you have the opportunity, look for layers of receding mountains outdoors and note the changes in color and lightness. When working with paint, it is often surprising how light the most distant mountains can appear in value.

STEP SIX

In this last stage, add more trees to add interest and contrast to the composition. Boost depth by adding violet to the tree shadows and subtly within the wildflowers. Bring more pops of blue and orange into the middle ground to create dynamic complementary color contrasts. Make any final adjustments to the painting, and finish by adding your signature!

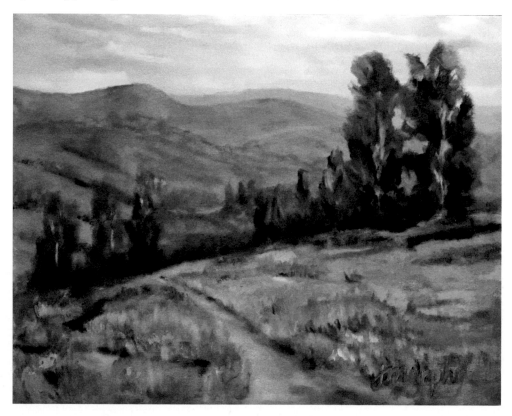

Conclusion

Color is a broad topic with the potential for great depths of study. This book covers the basics as it relates to painting, but there is so much more to discover. Applying your understanding of color is part technique and part intuition, and the best way to nurture your intuition is to practice. Take the next step and create your own series of paintings focusing on use of color. Give yourself ample opportunities to choose color schemes, evoke specific moods, play with color and light, and try new combinations of paints and pigments.